500

Digital Illustration

Hints, Tips, and Techniques

RotoVision

A RotoVision Book
Published and distributed by RotoVision SA
Route Suisse 9, CH-1295 Mies
Switzerland

RotoVision SA, Sales & Editorial Office
Sheridan House, 114 Western Road
Hove BN3 1DD, UK

Tel: +44 (0)1273 72 72 68
Fax: +44 (0)1273 72 72 69
E-mail: sales@rotovision.com
Web: www.rotovision.com

10 9 8 7 6 5 4 3 2 1

ISBN: 978-2-88893-086-0

Designed by Studio Ink
Art Director for RotoVision: Tony Seddon
Cover design: Lisa Båtsvik-Miller
Typeset in Interstate and Eviltype

Reprographics in Singapore by ProVision (Pte) Ltd.
Tel: +65 6334 7720
Fax: +65 6334 7721

Printed in Singapore by Star Standard Industries (Pte) Ltd.

500 Digital Illustration

Hints, Tips, and Techniques

The easy, all-in-one guide to those inside secrets for better image-making

Compiled by **Luke Herriott**

Contributing authors **Hannah Gal, Robert Brandt, Jim McCall, and Simon Danaher**

Contents

Hardware

Photoshop

Painter

Illustrator

Flash

Cinema 4D

3ds Max

Introduction

500 Digital Illustration, Hints, Tips, and Techniques introduces you to six of the most inspiring and useful digital software packages for creating both 2D and 3D illustrations.

Anyone with a computer and a printer now has an artist's studio, photography studio, film studio, printing press, and laboratory on their desk. They also have in their employ an army of technicians, experts, and mathematicians built into the software that silently work behind the scenes to achieve your objectives—you need only learn how to control them. Control and vision are the keys; without them your work will never expand beyond the results of default settings and examples in the instruction manual. Practice, find your own voice, and beware the path of least resistance.

We have chosen six specific pieces of software in three categories of digital illustration to cover the best and most likely tools you will have at your disposal, and the widest range of techniques. Adobe Illustrator and Adobe Flash are among the best-known for work with vector illustrations, while Adobe Photoshop and Corel Painter are ideal for working with raster (pixel) based images, each with their own strengths. For 3D modeling, Autodesk's 3Ds Max is an industry standard in many areas and Maxon Cinema 4D offers the same potential for Mac users, along with modularity.

The history of art is punctuated with paradigm shifts initiated by changes in technology. Initially these were restricted to the discovery of new pigments, increasing the palette of colors available, then new media and surfaces such as oil paint and canvas. As with writing, an enormous shift took place with the invention of the printing press and lithography, opening up new markets for artists' work and a way of reproducing it on an almost limitless scale. While the distinction grew between commercial and fine art, new techniques began to proliferate and styles diversified.

As soon as computers appeared on the scene, graphic designers began to experiment with the new potentials for layout and illustration. Photographers were quick to see the potential too and the areas where these three fields overlap were the first to produce distinctive new approaches. The interface between man and machine

Expand your mind with Your Magic

was at first a limitation, but people learned to draw with a mouse and later with graphics tablets that are now sensitive to tiny inflections of the hand. Software has become ever more sophisticated, versatile and capable, belying fears that standard filters would reduce computer illustration to a few predictable clicks of the mouse.

Computer models have added a new dimension to the potential for digital illustration. Animation has led the way, utilizing the obvious advantages of working with a model that can be adjusted for each frame rather than being redrawn. Lighting, textures, transparency, perspective, and proportion can all be simulated and endlessly adjusted. What is more, if a series of images is required the model or viewpoint has only to be repositioned and a new illustration is produced with very little extra work. Some skills very different from those of a traditional artist are needed, but the results and the potential are no less exciting, and it's a very young artform.

Spare a thought for those people on the list of credits that appear while your software is launching–they have laid the groundwork for a remarkable revolution in the way we express ourselves. Now it's up to us to fulfil its potential.

Robert Brandt

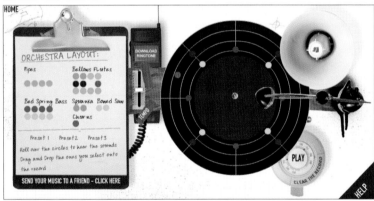

Hardware

Getting started
Before you can begin working with any of the illustration programs covered in this book, it's a good idea to check your hardware options. Advances in technology mean that there is a vast range of cameras, computers, storage units, and printers available to the digital illustrator. This chapter will help you find the right kit to suit your creative needs, and your budget!

Cameras
Digital illustration often uses photography as a starting point or as a feature of the final artwork. It is important to ensure we are using the correct equipment to capture digital images. Here, we consider the choices available for cameras, scanners, and other accessories.

001 Camera formats

Digital cameras are available over a wide price range. Generally, the higher the price, the better the quality of image. Although this book is primarily concerned with using digital imagery within an illustration and not actually taking photographs, it is still important to consider the differences between these cameras.

002 Resolution

Digital image resolution is measured in megapixels (M), which means one million pixels. This is one of the most important technical specifications to look for in a camera. A digital photograph comprises millions of pixels. The exact amount in any image will determine how much it can be enlarged. For example, a 5M camera will record a picture with physical dimensions of 2,592 x 1,944 pixels, which amounts to about 5 million pixels (5,038,848 to be precise). This image can comfortably be printed at letter paper size (A4) or bigger without the pixels becoming visible in the print. Larger files from 8M or 12M cameras can easily be enlarged to tabloid (A3) size or greater without any loss of quality.

003 Compact cameras

The quality of compact digital cameras has greatly improved recently. The cheapest models often start with a resolution of 3M. More expensive cameras have a resolution of 8M or more.

004 Lens quality

While resolution is very important, image quality is also determined by the lens. This is one reason why larger cameras such as SLRs (single-lens reflex cameras) are often more expensive.

005 SLR cameras

Single-lens reflex cameras normally have interchangeable lenses, and some can use optics designed for film cameras. Very common are 10M SLRs, though professional, more expensive models can capture up to 15M. Undoubtedly, this figure will rise in the future.

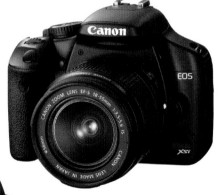

006 Cellphones

Even a 2M camera in a cellphone can produce images whose quality is relatively decent if processed correctly in Photoshop and not enlarged too much.

Computers

The most important piece of equipment required for digital illustration is a computer. These come in all shapes, sizes, and prices.

 ## Apple Mac or PC?

Your choice of computer will probably be determined by the other uses to which it will be put as well as personal preference. Apple Macs tend to be the choice of professional illustrators, designers, and photographers, though for home and office users there is more software available for PCs. Illustration programs such as Photoshop, Painter, Illustrator, Flash, and Cinema 4D run perfectly well on both systems, providing the computer has sufficient memory and processing speed. The program 3ds Max currently only runs on a PC.

 ## Laptops

Despite their small size, laptops can be as powerful as desktop computers, though they tend to be more expensive. Their portability, however, gives the user the freedom to work anywhere.

Processing speed

A computer's ability to perform and process information quickly and efficiently is expressed in gigahertz (GHz). For digital editing, a minimum of 1GHz is recommended. Most modern computers have this capacity.

 ## Desktop computers

Some desktop computers come with integral monitors, rather than having a separate monitor and computer tower. Buying such a desktop computer can be an advantage in terms of having an efficient, uncluttered workspace, but if the monitor fails or is damaged, you effectively have lost the whole computer. If you buy a computer with an integral monitor, it's good practice to back up your work onto a separate external hard disk, regardless of what type of computer you have.

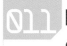 ## RAM (Random access memory)

When a computer program is running, it uses RAM to process files. RAM is expressed in megabytes (MB) and gigabytes (GB). One gigabyte is 1,000MB.

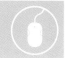

012 Hard drive

Applications, programs, and files are stored on a computer's hard drive, which commonly has the capacity to store more than 80GB of information. For efficient working, it is prudent not to fill this drive. For long-term storage, especially of images, it is worth buying an external hard drive.

013 Screens

Although traditional CRT (cathode ray tube) computer screens are still used, many people now prefer the slimmer LCD (liquid crystal diode) screens, which are standard with laptops. LCDs are more expensive than CRTs but take up less desk space.

014 Interactive pen displays

Interactive pen displays allow you to work directly on the screen with a pressure-sensitive, ergonomic pen–rather like working with pen and paper. This allows you to work more quickly and naturally. Screens like these can, however, be quite expensive.

015 Efficient working

When using your computer, work in as much comfort as possible. Invest in a chair that encourages good posture and supports your back. If necessary, provide support for your wrists so that they don't become strained. Ensure that your screen is at the correct eye level and that the room is well ventilated. If using the computer for a long period, take plenty of breaks. One of the disadvantages of using a laptop is that, because of its small screen, the user tends to hunch over it instead of sitting upright.

016 Flatbed scanners

Flatbed scanners are the most popular and economical types of scanner, and will scan artwork (photographic prints, book pages, and anything else on paper) up to letter paper (A4) size, though larger professional models are available. Most flatbed scanners contain a transparency hood, which allows negatives or transparencies to be scanned. Objects that you find in daily life can be scanned as images into your illustrations.

017 Scanning resolution

The resolution at which you scan should be determined by the original size of the image to be scanned and the proposed size of the finished artwork. Resolution is measured in pixels per square inch (ppi). A resolution of 300dpi will be adequate for letter paper (A4) artwork to be reproduced or printed at the same size, while a 35mm negative would need to be scanned at more than 2,000ppi to be reproduced at letter paper (A4) size.

018 Graphics tablets

Graphics tablets, which comprise a pen and a small tablet, allow much finer and more accurate manipulations to be made to imagery, and are much easier to draw with than a mouse. They also usually come with a cordless mouse that can be used on the tablet for normal controls. They are available in a range of sizes.

Digital storage

Digital imagery soon takes up a lot of space on your computer's hard drive, so other storage options should be considered.

019 CDs and DVDs

CDs and DVDs are very useful for storing and distributing digital images. A CD can hold up to 800MB of data and a DVD more than 4GB of data.

020 External hard drives

The preferred method for long-term storage is an external hard drive. The most powerful can currently hold up to 1,000GB, known as 1 terabyte (TB), though this figure will rise. Smaller portable pocket hard drives can be useful for transferring data between computers.

021 Memory sticks

For temporary storage and transferring files from one computer to another, small memory sticks, which plug into a USB socket, are very practical. They store anything between 256MB and 4GB.

Printers

Once you have created your digital illustrations you will need to print them. There is a great variety of printers available for both home users and professionals.

023 Color laser printers

A color laser printer is considerably more expensive than an ink jet printer to buy, although its running costs are generally cheaper. It is, however, much faster, more reliable, and thus better for longer print runs.

022 Ink jet printers

The ink jet printer is the most versatile printer for home use and can produce outstanding prints. Most printers will print up to letter paper (A4) size, though many professionals use either tabloid (A3) machines or even larger models that print from a roll of paper. More expensive printers naturally have more features, faster print speeds, and more available inks, but with some care and preparation even the cheapest desktop printers can produce good-quality prints.

024 Large-format printers

The large-format ink jet printer can print images up to 60in (152.4cm) wide. The length is only determined by the amount of paper on the roll. These printers are ideal for anyone who will need to create high-quality, outstanding, and long-lasting large-format, exhibition, and saleable prints, digital art, and contact proofs. The printers are very expensive, however, so unless you intend to output work of this scale on a regular basis you are probably better off paying a repro house to do it for you.

Adobe Photoshop

has become synonymous with photographic manipulation, but it is also used by illustrators for digital painting. With a graphics tablet, the customizable brushes can create a huge range of effects including some very close to traditional painting styles. Photoshop can also be used to manipulate scanned-in artwork.

Getting started

025 Creating a new image

Go to File > New. Name the file and under Background Content set the color of your choice. Depending on the intended end use of your image, enter Resolution. Set Width and Height, and see the new image size displayed bottom right of the New dialog box.

026 Viewing print size on screen

To see the size of your image as it would look in print, go to the main menu and choose View > Print Size. The image on screen will automatically shrink or increase in size, depending on the Width, Height, and Resolution you set.

027 Presenting images as a contact sheet

Place your images in a single folder and go to File > Automate > Contact Sheet. Under Thumbnails set Columns to 5 and Rows to 6, and under Units choose to view as pixels, inches, or centimeters. Under Source Images click Folder, and select the folder containing the images. From CS4 onward the contact sheet functionality has been moved to Bridge, but it is possible to retain this feature by copying the plug-in from the older CS3 Plug-ins folder. It still works perfectly well.

028 Color profile

If you are not sure what color profile you wish to use or do not want to color-manage your work at all, go to File > New and in the New dialog box click on Advanced. Under Color Profile, select Don't Color Manage This Document.

029 Instant web gallery

Place your images in a new folder and go to File > Automate > Web Photo Gallery. Under Site > Styles choose the stylish Dotted Border-White On Black. Under Source Images choose Folder and set Options to General. Go to Source Images and click Choose to open the folder containing your images. From CS4 onward the Web Gallery feature has been removed, but the plug-in can be copied from the older CS3 Plug-ins folder and will still function.

030 Free Transform scaling and distorting

To freely scale or distort a selection, go to Edit > Free Transform. To adjust size and proportions, simply pull the handles showing around the Selection.

031 Free Transform rotating

To freely rotate a layer or selection, go to Edit > Free Transform. Move your stylus or mouse over the edges of the selection and see a curved arrow appear. Drag the arrow in any direction to perform the rotation.

032 Purge

To free memory used by the History palette, Undo command, or the clipboard, go to Edit > Purge and select the item you wish to clear. The Purge command cannot be undone so use it with great caution.

033 Canvas size

To increase space around an image, go to Image > Canvas Size. In the Canvas Size dialog box, go to Anchor and click on the center square. Choose metric or imperial measurements and add 50cm (19.68in) to Width and 50cm (19.68in) to height. The blank new space will now surround your image, ready for editing.

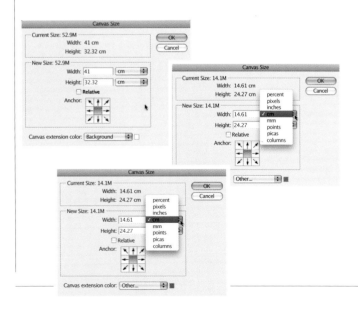

034 New adjustment layer

An Adjustment Layer lets you apply effects temporarily. These effects can be adjusted or removed at any point. Click on a layer in the Layers palette to select it. Go to Layer > New Adjustment Layer > Hue/Saturation, name the layer and click OK. The Hue/Saturation dialog box will open up. In the Hue/Saturation box choose Preview to see your changes in real time. Adjust Hue, Saturation, and Lightness sliders, and click OK. In the Layers palette, a Hue/Saturation icon will appear next to the affected layer's name. From CS4, a dedicated Adjustment Layer palette has been introduced to improve workflow further.

035 Load selection

Create a selection using the Rectangular Marquee tool. Go to Select > Save Selection and name your Selection Rectangle. Click anywhere on the image, or press CMD+D to deselect. Go to Select > Load Selection and in the Load Selection dialog box go to Source > Channel. Choose Rectangle and the saved Selection will appear in your image.

036 Expanding and contracting selections

Use the Lasso tool to create a Selection. To increase the size of the Selection go to Selection > Modify > Expand and enter a number of pixels. If the selection is still too small, enter a higher number. To reduce the size of the Selection go to Select > Modify > Contract and enter a number of pixels.

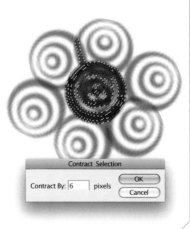

037 Filter Gallery

Use the rectangular selection tool to create a selection and go to Filter > Filter Gallery. Choose Artistic and click on any filter for an instant preview. You can now click on as many filters as you wish to instantly view their effect on your selection.

038 Pop Art look

For an instant Pop Art look, go to Filter > Pixelate and choose Color Half Tone. Set Max Radius to 8 and click OK. Experiment with Max Radius level to create a variation on the Pop Art effect.

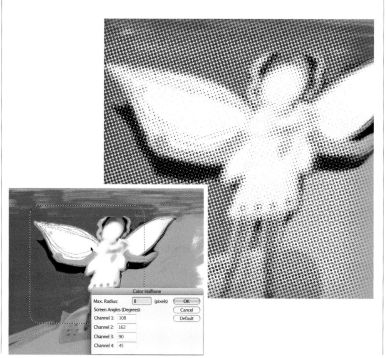

039 Freeform Pen tools

The Freeform Pen tool lets you freely draw a path onto your canvas. The line you draw is made of Anchor points that can be adjusted once your Path is complete. In the Toolbox choose the Freeform tool and drag your mouse/stylus on the canvas as you would a pencil. The Freeform Pen Tool can draw a Path only, or fill the Path with color as you draw. To automatically fill a Path with Foreground color, after selecting the Pen from the Toolbox, go to the Options bar and click on the Shape Layer icon, second icon from left. For a Path only, in the Options bar, click on Freeform Path tool, sixth from left.

042 Special effects brushes

In the Toolbox select the Brush tool. In the Options bar, click on Brush to open the Brush Preset Picker. Click on the little triangle top right and from the pop-up list choose Special Effects Brushes. Select the brush titled Ducks Not in A Row as an example, and apply a stroke onto your canvas.

040 Drawing a shape

Select the Shape tool in the Toolbox. In the Options bar click on the Shape icon and select a Shape. Drag your mouse or stylus on the image to draw the shape. You can see the Shape being created as you drag. The further you pull away from the starting point the bigger the shape; the closer you are to the starting point the smaller the shape.

041 Wet brushes watercolor

In the Toolbox select the Brush tool. In the Options bar, click on Brush. In the Brush Preset Picker box that opens, click on the little triangle top right and choose Wet Media Brushes > Watercolor Light Opacity. Set a low Brush Hardness and apply Watercolor brush strokes to your canvas.

043 Displaying all shape Icons

Photoshop Shapes are split into subjects such as Animals, Arrows, and Nature, among others. To display one of the groups, first select the Shape tool in the Tool Box. In the Options bar, click on the little triangle by the Shape icon. In the box that opens, click on the little triangle top right and make your choice.

044 Displaying all shapes at once

To display all shapes at once, select the Shape tool in the Toolbox. In the Options bar click on the little triangle by the Shape icon, and in the box that opens click on the little triangle top right. From the pop-up list, select All.

045 Texturizer

Use the Marquee tool to create a selection. Go to Filter > Texture > Texturizer. In the Texturizer dialog box, set Scaling to 100 percent and Relief to 5. The realistic Canvas effect will show in the Preview window. Click OK to apply to your selection.

046 Rendering lighting effects

Make a selection using the Rectangular Marquee tool. Go to Filter > Render > Lighting Effects, and under Light Type select Directional. Select the Red Texture Channel as an example, and click the White is High box. Slide Height to 40 and see a 3D texture enhance your selection.

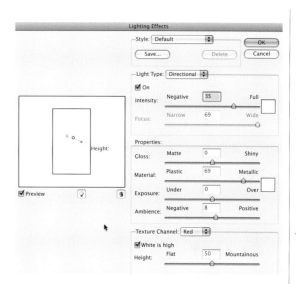

047 Copying a layer

To copy a layer quickly, go to the Layers palette, and while pressing ALT drag the Layer up or down to another layer slot. It will be duplicated and automatically named as Copy 1. A second copy you create will be automatically named Copy 2, and so on.

048 Applying layer style

In the Layers palette, double click on a layer to open Layer Style. You can apply Shadow, Outer or Inner glow, and Bevel and Emboss, among other effects. Click the square by Drop Shadow and set Opacity to 100 percent. Click OK and see the name of the effect displayed in the Layers palette.

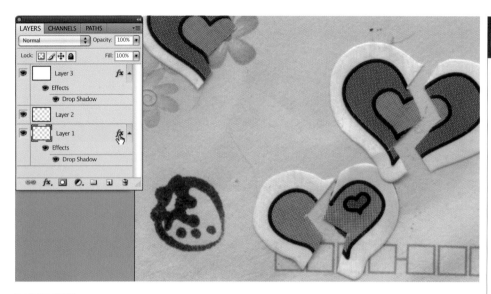

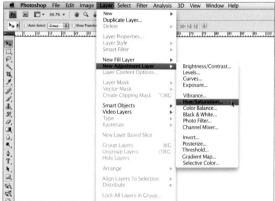

051 Adjustment layer

The release of the CS4 edition of Photoshop has introduced a new Adjustments palette that makes creating adustment layers a much simpler task to perform. If you prefer, adjustment layers can still be created in the traditional manner via the Layer > New Adjustment Layer menu.

049 Copying a Layer Style effect

You can apply the same Layer Style effect to other layers without opening Layer Styles again. In the Layers palette, while pressing ALT, drag the Layer Style effect from one layer to another.

050 Saturation

Choose Layer > New Adjustment Layer > Hue/Saturation. Click the Preview box. Under Edit select Master and move the Saturation slider to the right to increase Saturation, or left to reduce it. To change Saturation of a single color click on Edit and select Yellow, Green, Cyan, Blue, or Magenta.

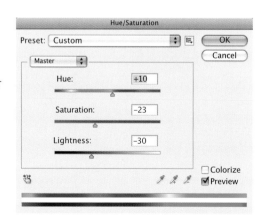

052 Saving a layered file

When saving a layered file in progress, you need to keep layers separate. Go to File > Save As, and in the Save As dialog box tick the Layers box. Next time you open this file, the layers will be exactly as saved.

053 Shortcuts

It is at times useful to view an image without any surrounding palettes. To hide all palettes on screen, press Tab once. To bring all palettes back into view, press Tab again.

054 Changing a background color

To change the default gray background color that surrounds your image, go to the Toolbox and select the Paint Bucket tool. Set a new foreground color and while holding Shift click on the gray background.

055 Screen mode

An image is sometimes easier to assess with a black background instead of the default gray. Click the very bottom icon on the Toolbox and hold. From the pop-up menu choose Full Screen Mode. Alternatively, press the F key to skip from one screen mode to another.

056 Quick layer selection

Instead of going to the Layers palette to select a layer, choose the Move tool in the Toolbar and while pressing CTRL click on any part of the image. A list of the layers will come up.

057 Resetting

Hold the ALT button and any Cancel option is changed to Reset. This is particularly useful when resizing. Go to Image > Image Size, press ALT, and watch the Cancel button change to Reset.

058 Target cursor

With Brush tool selected, click anywhere in the image and press Caps Lock. The cursor changes to a target-like shape, allowing greater accuracy. When you let go of Caps Lock, the cursor goes back to normal.

059 Straight line

For a straight line when drawing or painting, hold the Shift key and click where you want your line to start. Now move to where you wish the line to end, and click again.

060 Deleting a layer

To delete a layer, select it in the Layers palette and click on the Trash Can icon at the bottom of the Layers palette. This will bring up a notice asking you to confirm the action.

061 Changing opacity

Reduce the number of trips to the menu or Options bar by using shortcuts. With the Brush tool selected, type the number 5, for example, to set a 50 percent Opacity, 3 for 30 percent, and so on. For a specific two-digit number like 82, just key the full number in.

062 Zoom shortcut

A handy Zoom shortcut is double clicking the Zoom tool for a 100 percent display. Another is double clicking the Hand tool to fit the image to the screen resolution.

Using type

063 Rotating type

With the Type layer selected go to Edit > Transform > Rotate. A bounding box will appear. Move the mouse or stylus around its edges and drag the curved arrows that appear. You can also go to Edit > Free Transform and drag the mouse or stylus around the bounding box.

064 Text viewing

Create your text and run the mouse over to select it. In the Options bar click on the Font list to open it and choose any font you wish to test. You can see the text changing in real time.

065 Entering text

To enter text, select the Text tool in the Toolbox and set Size in the Options bar. Click on the image, where you want the text to start, and enter your text. To move to a new line, press Enter.

066 Warping text

Select the Text tool and create your text. Drag your mouse or stylus over the Text to select it and go to Layer > Type > Warp Text. Under Style choose the Warp setting of your choice.

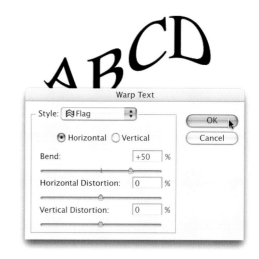

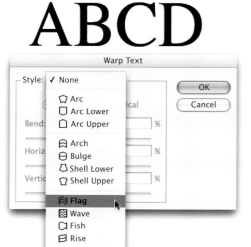

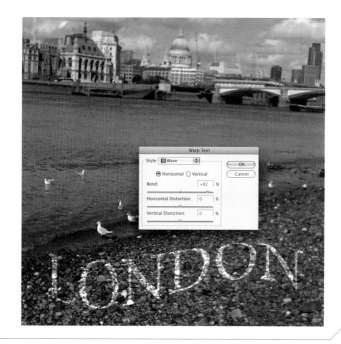

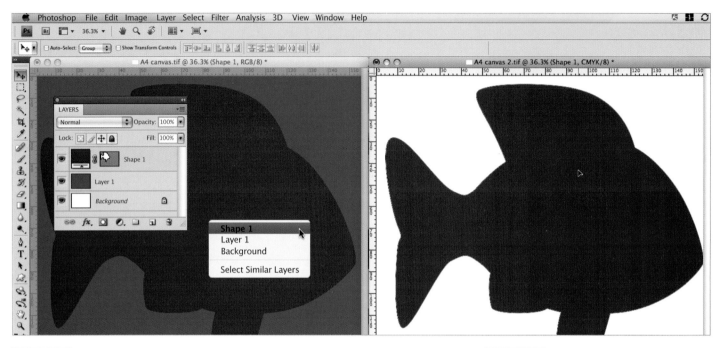

067 Moving a layer from one open image to another—Part 1

To move a layer from one open image to another, click on the layer in the Layers palette to select it. Go to Select > All, followed by Edit > Copy, and click on the image this copied to. Go to Edit > Paste and see the new file appear as a new layer in the Layers palette.

068 Moving a layer from one open image to another—Part 2

Press CTRL while clicking on the image using the Move tool. From the list that opens up, choose the layer you wish to move. Use the Move tool to drag the layer to another open image. The new layer will show in the Layers palette.

069 Selecting layers

To select a layer, click on it in the Layers palette. Alternatively, hold down CTRL and using the Move tool, click on the canvas. This will bring up a list of layers to choose from.

070 Deleting layers

To delete more than one layer at a time, press CMD while selecting the layers in the Layers palette. Hold down CMD while you click on the trash icon, and see layers vanish.

071 Selection tips

To constrain a selection to a perfectly proportioned circle or square, choose the Elliptical Marquee tool. While dragging the mouse or stylus over the canvas, hold down the shift key. To start drawing from the center of your image, hold the Alt key while creating the selection.

072 Speeding up

Speed up your system by deleting unused layers. In the Layers palette identify "dormant" layers and drag them to the trash.

073 Quick black and white

To remove color from a Selection press CMD + Shift + U. The Selection will be desaturated instantly. To Desaturate an entire layer, click on the layer in the Layers palette to select it and press CMD + Shift + U.

074 Zooming in and out

To Zoom in, go to View > Zoom in, or use the Zoom Tool in the Toolbox. You can also zoom in by pressing CMD and the plus sign. To zoom out, press CMD and the minus sign together.

075 Tile images

Having several images open at once creates clutter, with overlapping images. Go to Window > Arrange > Tile and Photoshop will arrange the open files neatly, ensuring all are visible. To close the files press CMD + ALT + W.

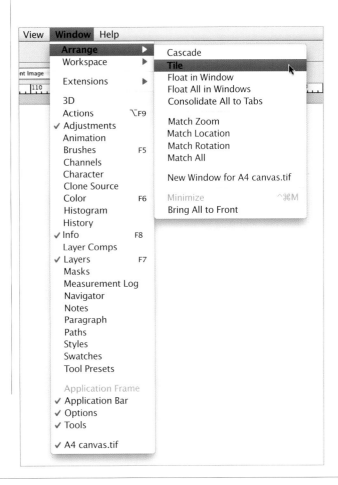

Original: "iStock_000003547092Medium.jpg" 5.49M

GIF 606.3K 111 sec @ 56.5 Kbps

88% dither Selective palette 128 colors

076 Saving for the web

To save a file intended for the web, go to File > Save For Web & Devices. In the dialog box that opens, click on 2-UP to see the original file on the left, next to the web version on the right.

077 Automating Photomerge

Photoshop lets you create a panoramic view by merging several photos together. Start by placing your photographs in a folder and go to File > Automate > Photomerge. Under Layout select Auto and under Use choose Folder. Click on Browse to open the folder and click the Blend Images Together box.

078 Hiding layers in palette

You can hide a layer from view by temporarily "turning it off." In the Layers palette, click on the Eye icon by a layer's name. To bring it back into view, click on the Eye icon again.

079 Naming layers

Make it a habit to always name your layers. Go to Layer > New Layer and enter a name that describes its content. You can also create a new layer by clicking on the little triangle top right of the Layers palette and choosing New Layer.

080 Changing the order of layers

To change the order of layers, drag them up or down on the Layers palette to a new location. Pressing ALT while dragging the layer to a new position will duplicate it.

081 Locking a layer

Lock a layer to prevent any changes being applied to it. Click on the layer in the Layers palette to select it. In the Layers palette go to Lock and click on the Lock icon to Lock All. To only lock the Layer in its position within the palette, go to Lock and click on the Cross icon, second from right.

082 Edit > Stroke

With the Rectangular Marquee tool, make a selection in your image. Under Edit > Stroke, enter 5 for Width and choose Outside for Location. Set Opacity to 100 percent and click the Color icon to Select Stroke Color.

083 Edit > Fill with Color

Make a selection in your canvas. Go to Edit > Fill, set Blending to Normal, and under Use, choose Color. In the Color palette choose a color and click OK. In the Fill dialog box also click OK and see your selection filled with color.

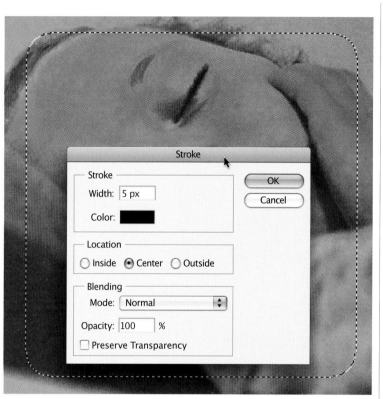

084 Opening Files

Go to File > Open and click on the name of the file you want to open. At times, not all files appear in the Open dialog box. If this happens, click on Enable All Readable Documents.

086 Montage

Start your Montage by going to File > New and creating your main image. Go to File > Open and select the first file for your Montage. Open it and go to Select > All, followed by Edit > Copy. Now click on your main Montage file to select it and go to Edit > Paste. The new file will now show as a new layer in the Layers palette. Open a second file for your Montage and continue to copy and paste its content into your main file. Repeat this process for the remaining files. If you would rather select more than one file at a time, in the Open dialog box, press CMD while clicking on file names.

087 Display brushes

Select the Brush tool in the Toolbox and click on the Brush icon in the Options bar. In the Brushes list that opens, click on the top right little triangle. You can now choose to view brushes as Large or Small Thumbnails, Text Only, or Stroke.

088 Display brushes—Stroke

To see actual brush strokes in the Brushes list, select the Brush tool in the Toolbox. Click on the Brush icon in the Options bar, and in the Brushes list that opens click on the little triangle followed by Stroke Thumbnail.

085 Edit > Transform > Warp

Use the Marquee tool to make a selection. Go to Edit > Transform > Warp and a bounding box will now surround your selection. Drag any square or circle on the box to see the Warping in action. You can drag any area at all within the bounding box for a great Warping effect.

089 Dry media

Dry Media Brushes include Pencils, Charcoals, Pastels, and Crayons. With the Brush tool selected in the Toolbox, click on Brushes in the Options bar followed by the top right little triangle. Choose Dry Media Brushes and get painting.

090 Wet media

Within Wet Media you will find different effect brushes, including oil and watercolor. Select the Brush tool in the Toolbox. In the Options bar, click on the little triangle by Brush. In the list that opens, click on the top right triangle and choose Wet Media Brushes. Choose your brush and paint away.

091 Filling with pattern

Create a Selection using the Elliptical Marquee tool. Go to Edit > Fill and under Contents choose Pattern. Set Blending > Mode to Normal, click on Custom Pattern, and select a pattern.

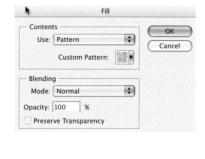

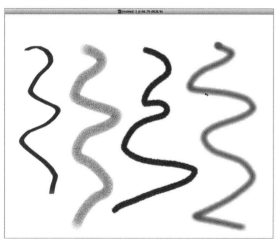

092 Image size

To change image dimensions go to Image > Image Size. If you want to keep proportions intact, be sure to tick the Constrain Proportions box. Choose Resample Image and under Document Size set new Width and Height of the new image.

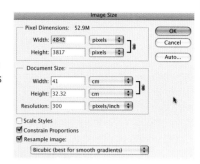

093 Bridge browsing

Bridge is a great workflow enhancing tool. Go to the main menu and under File choose Browse. Double click on any folder icon to open it and see handy previews of the images it contains.

094 Feathering

To see Feathering's softening effect in action, start by clicking on the Selection tool in Toolbox. Under Feather in the Control panel enter 10 and create a selection. Go to Select > Deselect and change Feather to 100. Create your selection. The first has hard, sharp edges while the 100 Feather level is soft.

095 Magic wand

You can add to and subtract from a Magic Wand selection. In the Options bar set Tolerance level and make your selection. To add to the selection, press the Shift key and click on the area to add. To subtract, press the ALT key and click on the area to remove.

096 Deselecting Shortcut

To remove a selection, you can click on any part of the image or go to Select > Deselect in the main menu. For a handy deselection shortcut click on CMD+D.

097 Clone tool

The Clone tool perfectly copies one part of the image onto another. Choose the Clone Stamp Tool in the Toolbox and in the Options bar set Opacity to 100 percent. Press ALT and click on the area or item you wish to clone. Select an area within the image for the new clone and drag your mouse or stylus over it. Continue until the entire item or area is cloned.

098 History palette

Go to Window > History to display your History palette. This handy palette stores and displays every change you apply to the image as you work. Clicking on any past step within it will take you "back in time" to this stage in the image making.

099 Art History brush

To use the Art History Brush, first go to Window > History to display the History palette. Here, choose the step you wish to make your snapshot, and click on the box next to its name to select it. This is now the source for the Art History Brush. Select the Art History Brush and in the Options bar choose a brush. In the Style menu set the shape of the stroke you wish to use and apply to the image.

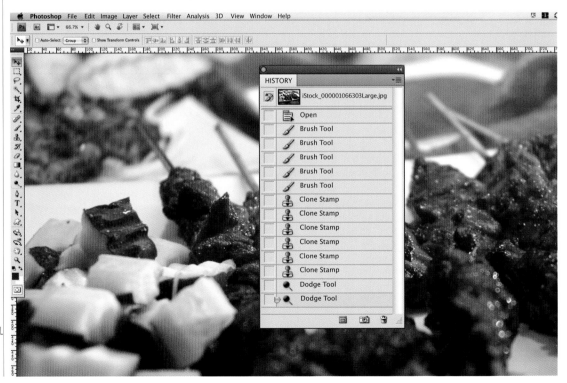

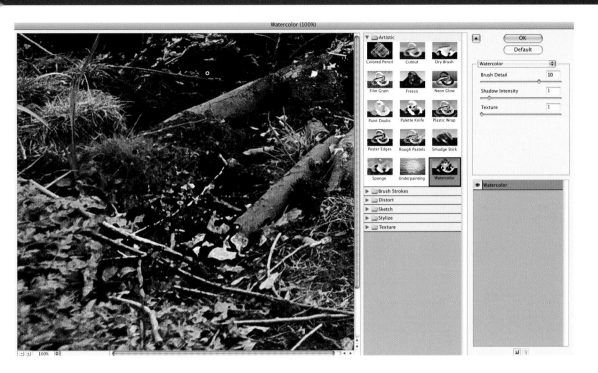

100 Filter search

Testing a filter on an entire image is time-consuming and unnecessary, especially when working on a large or multilayered image. Use the Rectangular Marquee tool to make a small selection, go to Filter > Filter Gallery, and choose the filter of your choice.

101 Smart Blur

Select an area in a digital photo where some unwanted pixellation has occurred. Go to Filter > Blur > Smart Blur. In the Smart Blur box, set Quality to High and Mode to Normal. Set Radius to 1.5 and gently move the Threshold slider to achieve the desired Blurring result.

102 Flattening an image

A high number of layers can slow you down, especially when working on a large image. When you reach the "finishing touches" stage, go to File > Save As and save your image as a layered file. Go to Layer > Flatten Image and go to File > Save As, give the flat file a new name, and continue to refine it.

103 Importing layers

You can move layers from one image to another. Start by having both images open on your screen and select the Move tool in the Toolbox. Click on a layer to select it in the Layers palette and drag it to the other open image.

Painter

Hannah Gal

Corel Painter

Corel Painter has a layout and toolset specifically designed for artists and illustrators. A lot of effort has gone in to making those used to working on paper feel comfortable with the program, and it can also convincingly reproduce the look of traditional media. With a graphics tablet, Painter is a medium that can help you to create beautiful work that feels handcrafted.

Workspace palettes menus

104 Customizing the workspace

Painter lets you create your ideal workspace. To rearrange the Painter workspace, simply drag the icon of a palette such as Layers, Mixer, or Colors, to the desired location on screen. To save the new workspace, go to Window > Arrange Palette > Save Layout and give the new workspace an easily recognizable name.

105 Creating a new custom palette

To create a palette containing your most often used brushes, open the Brush Selector bar. Drag a brush icon onto the screen to create a new Custom palette. From the Brush Selector bar, drag your chosen brushes into the new palette.

106 Custom palettes for different tools

You can create a separate custom palette for often used Colors, Papers, and other tools. A palette can be dedicated to a certain style like watercolor landscapes, or can be a combination of tools.

107 Palette control

To move icons within a new custom palette, click on an icon to select and drag it while pressing Shift. To delete an item from the palette, hold down the Shift key, and simply drag the icon off the palette.

108 Saving the custom palette

When you are happy with the content and layout of a new custom palette, save it by going to Window > Custom Palette > Organizer. From the pop-up list, select the palette, click on Rename, and give the palette a memorable name.

109 Undo

Under Preferences > Undo set the number of Undo levels you wish to edit. The default is set to 32. Bear in mind that the higher the level of Undo is, the slower your system, especially when working with large and multilayered files. It is better to start with a low 5 and increase according to need.

110 Recording a brush stroke

Painter lets you record a brush stroke and save it. Open the Brush Selector bar, click on the little triangle in the top right and choose Record Stroke. Painter will automatically record the next brush stroke you apply.

111 Stroke playback

Open the Brush Selector bar, click on the little triangle in the top right, and choose Record Stroke. Click on the triangle top right of the Brush Selector bar and choose Playback Stroke. The strokes you apply from now on will be identical to the stroke you recorded.

112 Auto playback

Open the Brush Selector bar, click on the little triangle in the top right, and choose Record Stroke. Click on the triangle top right of Brush Selector bar, choose Auto Playback, and see Painter automatically build up the image with strokes identical to the one recorded.

113 Saved stroke variants

A recorded stroke maintains its shape when you change brush variants or select a different brush. A typical Van Gogh stroke, for example, can keep its shape for the entire image but its color will change for different parts.

114 Shortcuts

Spare yourself repeated trips to the main menu by adopting handy shortcuts. Click the Tab key once to hide all palettes so only the image remains on screen. Press Tab again to show all palettes.

Compositing tools

115 Rotating a selection

To Rotate a selection, go to Effects > Orientation. The selection turns into a square with a handle on each corner. Make sure the Rotate dialog box does not cover your selection and drag one of the handles to rotate.

117 Constraining the scale aspect

Go to Effects > Orientation > Scale to open the Scale Selection box. Click to Constrain Aspect Ratio so selection proportions stay the same as its size changes.

116 Scaling a selection

To Scale a selection, go to Effects > Orientation > Scale. The selection turns into a square with four handle corners. Make sure the Scale dialog box does not hide your selection and drag any of the handles to scale.

118 Distorting

To distort a selection, go to Effects > Orientation > Distort. Drag any of the square corners or sides and see a preview of the distorted shape. The better (slower) option will give a more accurate preview of changes but takes longer to process.

Drawing and painting

119 Tracing paper

Painter's tracing paper works just like the traditional version. Start by going to File > Clone followed by Canvas > Tracing Paper. The image will appear as if it is under a sheet of traditional tracing paper.

120 Tracing paper opacity

Go to File > Clone followed by Canvas > Tracing Paper. Click and press on the Tracing Paper icon top right of the image. From the pop-up list, select the desired Tracing Paper Opacity level.

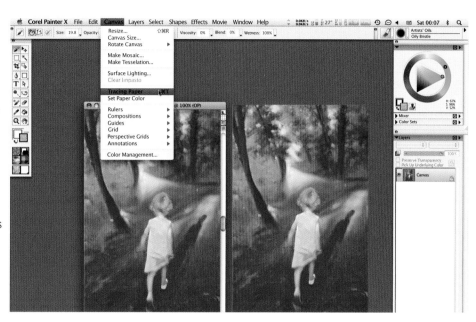

121 Drawing progress

Go to File > Clone followed by Canvas > Tracing Paper. You can now draw over the image to trace the original underneath. To check your progress quickly as you draw, click on the Tracing Paper icon to turn it on and off.

122 Ditching the mouse

To get the best out of Painter, swap your mouse for a stylus. A graphics tablet brings digital creativity closer to real life with significant controls over Pressure, Sensitivity, and Tilt. Holding a pen/pencil-like tool, you can better simulate real-life drawing and painting.

123 System preferences

Make System Preferences > Wacom Tablet your first stop. Choose the Tablet, Tool, and Application you are using, and go to Pen. Under Tip Feel click on Details and move the Sensitivity slider toward Soft for a lighter touch, or Firm for the opposite. Test your stroke in the Try Here box.

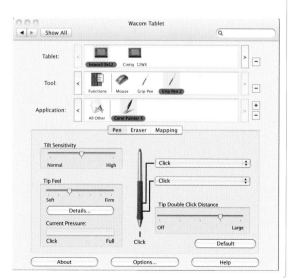

124 Brush Creator

Go to Window > Show Brush Creator > Stroke Designer. This is where you choose a brush and its variant, adjust its settings, and use a large preview window to test it. Every possible aspect of the brush and its stroke is available here.

125 Brush Creator practice

To design a brush stroke go to Brush Creator > Pencils > Thick and Thin Pencil, Dab Type Circular, Method Cover, Subcategory Grainy Flat Cover, and set Expression to None. Apply a stroke in the Preview window. Change Subcategory to Soft Cover and Expression to Pressure. Apply a stroke to see the different effects.

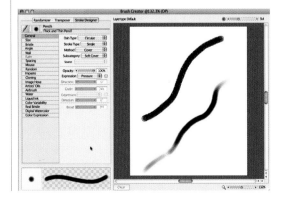

126 Brush Creator control

As you work, leave the Brush Creator box open but hidden away. When you need to make adjustments to your brush, go to Window > Show Brush Creator to bring it up.

127 Brush Creator pad

Use the Scale slider bottom right of the Brush Creator box to scale your preview pad strokes from 25 percent to 800 percent. Click on Clear at the bottom of the box to erase all and start again.

128 Brush size shortcut

If you only need to change brush size but none of its other settings, do not open Size category on the left controls panel. Instead, adjust the Brush Size slider top right of the preview pad. As you adjust it, the brush icon under Size category automatically updates.

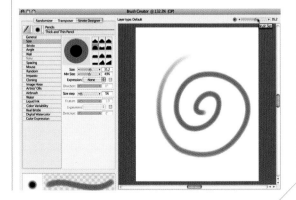

129 Property bar

For quick access to essential settings, go to Window > Show Property bar. Options within it automatically change according to the tool selected. Click on Brush tool and Property bar controls will include Size, Opacity, Resat, Bleed, and Jitter, as well as Stroke type.

130 Libraries

Papers, Textures, Gradients, and Patterns are organized in libraries. This is where the many varieties of the tool are stored. Click on the Paper palette at the bottom of the toolbox, for example, to view the list of papers available. Alternatively, go to Window > Library Palettes > Show Papers.

131 Custom library palette

Click on the triangle in the top right of the Paper palette and select Paper Mover > New. Name the palette and drag selected papers from the library on the left to the new one on the right.

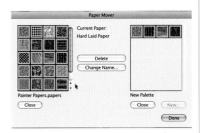

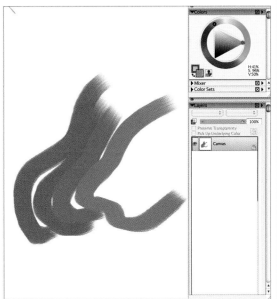

132 Blending pastels

Painting with pastels means blending adjacent areas with one another. To see this in action, apply a few pastel strokes onto your canvas. Go to Blenders > Soft Blender Stump 20, and just as you would with your finger, click on the area to be blended and repeatedly drag the brush away.

133 Mixer palette

The Mixer palette works just like the traditional artist's palette, with controls just below the pad. Go to Window > Color Palettes > Show Mixer. Use the Apply Color tool (second from left) to place colors on the pad, and Mix Color (third from left) to mix them together. Use Eyedropper to sample color.

134 Fade

Fade is a highly useful but often forgotten feature. Apply a brush stroke at 100 percent Opacity and go to Menu > Fade. Move the slider to set the Undo amount at different levels and see the effects.

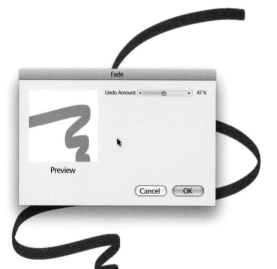

136 Pressure sensitive

For a real-life painterly effect, go to Brush Creator > Impasto. Choose Artists' Oils > Oily Bristle and set Expression to Pressure. Go to Size > Min Size 20%, Expression > Pressure. The stroke will now respond to the pressure you apply, varying size and opacity accordingly.

135 Impasto

Impasto is one of Painter's greatest features. It simulates real-life brush strokes with a convincing 3D effect. Go to Window > Show Brush Creator. Choose Artists' Oils > Impasto > Draw To Color and Depth. Set Depth to 100 percent and apply a stroke. Increase Depth to 150 percent to see the enhanced 3D effect.

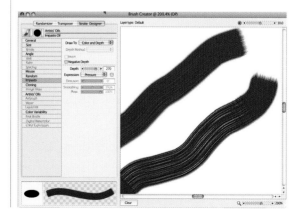

137 Grain

One of the settings in the Property bar is Grain. Painter applies the paint to texture peaks so when Grain setting is increased, more paint penetrates the texture and it looks less grainy. A decreased Grain setting means less paint penetrating the texture and a more grainy effect.

138 Grain peaks and valleys

Go to Brush Selector Bar > Chalk > Square Chalk and in the Property bar set Grain to 14 percent. Apply a stroke. Via the little triangle top right of Paper Selector, choose Invert Paper. Set a different color and apply it over the previous stroke. The first stroke covers texture peaks where the second covers valleys.

Liquid ink

139 Liquid ink settings

From the Brush Selector bar choose Liquid Ink > Smooth Camel. In Brush Creator choose Liquid Ink and under Ink Type select Ink Plus Color. Apply a stroke and a new layer automatically shows on the Layers palette. Double click on it to open Liquid Ink Layers Attributes for adjustments.

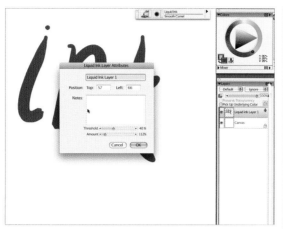

141 Liquid ink scrape paint

In Brush Creator choose Liquid Ink > Tapered Bristle 15. Under Ink Type choose Ink Plus Color and apply a few strokes. Under Ink Type choose Resist and run the stylus over previously applied strokes. Each stroke scrapes paint away.

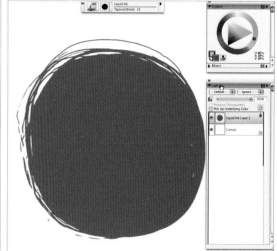

140 Liquid ink amount

In Brush Creator choose Liquid Ink > Tapered Bristle 15. Under Ink Type choose Ink Plus Color and apply a few strokes. In the Layers palette click on the Liquid Ink layer to open Liquid Ink Layer Attributes and set Amount to 40 percent. Click OK to see your stroke become magically rounded.

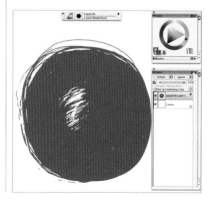

Working with Real Bristle brushes

142 Real Bristle

Real Bristle brushes add realism to digital painting by controlling different parts of the traditional artist brush. Open the Brush Selector bar and choose Real Bristle or go to Window > Show Brush Creator > Real Bristle and click on Enable Real Bristle.

143 Real Bristle brush basics

To see Real Bristle brush controls in action, go to Window > Show Brush Creator > Impasto > Smeary Flat. Under Real Bristle > Enable Real Bristle and go to Brush > Fanning > 30 percent and apply a stroke. Set Fanning to 100 percent and apply a stroke next to the previous one.

144 Designing a Real Bristle brush

Open Brush Creator and choose Real Bristle Brushes > Real Tapered Bristle. Under Impasto set Draw To Color and Depth, Depth Method Uniform, Depth 10-15, Expression Pressure, Smoothing 100 percent, and Plow to 100 percent. Apply a stroke to see the 3D effect.

Textures, patterns, and weaves

145 Textures

Open Brush Creator and choose Pastels > Square Hard Pastel 40. Under Impasto select Draw To Color and set General Method to Cover, Subcategory to Grainy Hard Cover. In the Property bar set Grain to 80 and apply a stroke. Change Grain to 14 and apply another stroke.

146 Watercolor effect

For a perfect simulation of real-life watercolor, go to Window > Brush Creator and choose Watercolor > Watery Soft Bristle 20. Under Water, set Wetness to 0 and apply a long stroke. Now set Wetness to 100 and see the brush in action.

147 Pattern Fill

Open a new file and use any of the Selection tools to make a selection. Click on the Pattern palette on the Toolbox or go to Window > Library Palettes > Show Pattern. Select a pattern and go to Effects > Fill and in the Fill dialog box choose Pattern. Set Opacity to 100 percent.

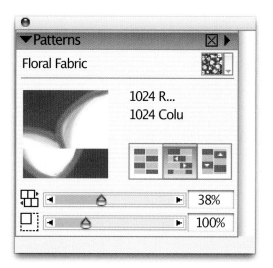

148 Patterns scale

Open a new file and make a selection. Open Patterns Selector
in the Toolbox and choose Floral Fabric. Click on the little
triangle in the top right and choose the Launch palette. In the
Pattern palette set Scale to 4 percent and go to Effects > Fill >
Pattern. Create a new selection and change Scale to 100. Fill
as before.

149 Pattern access

Click on the little triangle top right of the Pattern Selector and
choose the Launch palette. In the launched Pattern palette the
selected pattern shows in a little square in the top right. You can
access the list of patterns by clicking on the tiny triangle next to it.

Papers

150 Paper control

To adjust paper texture, first go to Window > Library Palettes > Show
Papers. Click on the little triangle on the right to launch the palette
and select a paper. Adjustments made to Paper Scale (top slider),
Paper Contrast (middle slider), and Paper Brightness (bottom slider)
are seen live in the small preview window.

151 Paper information

In the Toolbox, click on the Papers palette followed by the little
triangle in the top right. From the menu choose the Launch Palette.
Move the top slider to Scale, the middle slider to Paper Contrast,
and the bottom slider to Brightness.

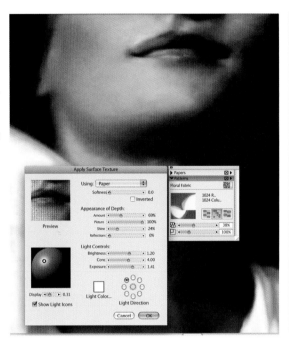

152 Controls from within the launched Papers Palette

Open the Papers palette and click on the little triangle top right
of the Launch Palette. To change the paper without leaving the
launched Paper Palette, click on the tiny triangle next to the top
right square.

153 Applying paper texture

To apply Paper Texture to your image,
go to Window > Library Palettes > Show
Papers, and click on the little triangle on
the right to the Launch Palette. Adjust Scale,
Contrast, and Brightness, and go to Effects >
Surface Control > Apply Surface Texture,
and under Using choose Paper. Adjust the
Amount slider to control effect intensity.

154 Fade

When you find a just-applied Surface Texture effect too intense, use
Fade to tone it down. Go to Edit > Fade and in the dialog box adjust
the Undo Amount slider.

155 Outputting

If your Painter image is layered, Painter will recommend you save it
as a RIFF file, the program's native format. A RIFF will preserve all
layer information intact and your canvas separate from the layers.

Selections

156 Selection tools

Use the Rectangular selection tool to make a selection anywhere on your canvas. Go to the Selection Adjuster tool, located to the right and just below the Selection tool. When you click on it, handles will appear on your selection. Drag any handle to adjust the shape. Press Shift while dragging to maintain proportions.

157 Saving a selection

When you are happy with the selection you have made, keep it for future use. Go to Select > Save Selection, and in the Save Selection box that opens up give it an easily recognizable name. When you next go to Select, you can choose Load Selection to open it up.

158 Easy tracing

Use an existing artwork or photograph to create a new sketch. Open your original image and go to File > Clone. Select All, Delete, and click on the Tracing Paper icon top right of the Clone image. You are ready to trace.

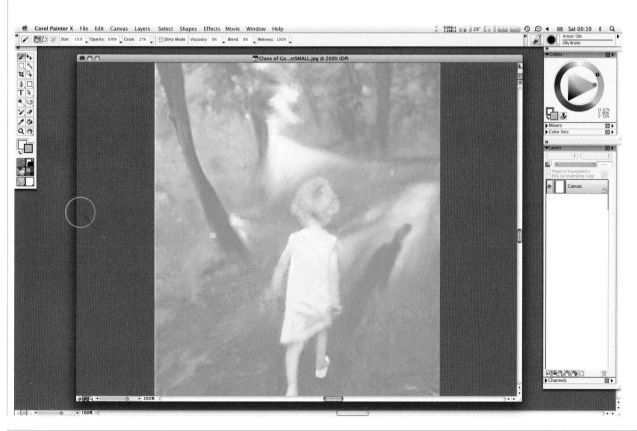

Using shapes

159 Better to import

Even though Painter lets you create and manipulate shapes, you might want to consider creating the main objects in a separate drawing program like Adobe Illustrator, and importing the vector artwork into Painter.

160 Shapes and layers

To paint on a shape you will need to convert it into a Pixel layer first. Use the Shape Selection tool in the Toolbox and click on the shape. Go to Shapes > Convert to Layer. Alternatively, click on the little triangle top right of the Layers palette, and from the menu choose the Convert to Default Layer.

162 Pen tools: Stroke and Fill

Select the Pen tool in the Toolbox. In the Property bar tick the Fill and Stroke boxes. Click on the Stroke box and select Yellow, and in the Fill box select Black. Click on the image to create a square shape. Be sure to close the shape.

161 Selecting a shape

Use the Circle selection tool to create a selection. Go to Select > Convert To Shape. Alternatively, in the Property bar, click on the triangle resting on a circle icon, first on the right.

163 Change shape stroke and color

To change the shape, Fill, or Stroke, select Shape in the Layers palette. In the Property bar click on the first icon on the right and open the Shape Attributes dialog.

164 Quick Curve

To create a freehand shape, choose Quick Curve in the Toolbox.
If you want your shape to fill automatically with color, be sure the
Fill option in the Property bar is ticked.

165 Tracing using page rotation

Painter lets you adjust the paper angle as you draw. Click and hold the Grabber tool
in the Toolbox to show the Page Rotation tool. Click on the image and drag to rotate
it. Once you reach the desired angle, click on the Brush tool to continue drawing.

166 Reverting page rotation

Click and hold the Grabber tool in the Toolbox to show the Page Rotation tool and adjust
the image angle. Double click on the Page Rotation tool in the toolbox to revert to the
original angle.

Image effects

167 Color matching

You can take the overall color from one image and apply it to another. Imagine, for example, Van Gogh's fiery colors on your original landscape photo. Open the image with the desired colors, and the image to apply them to. Select the destination image, go to Effects > Tonal Control Match Palette, and choose the source image.

168 Dodge and Burn tools

Dodge and Burn tools lighten and darken targeted parts of an image. To lighten an area within the image, select the Dodge tool from the Toolbox, set the Size in the Property bar to 12 and Opacity to 20 percent, and drag repeatedly over the area.

169 Surface texture paper

To apply a textured paper effect to your image, first open the Paper Selector and select Artists Canvas. Go to Effects > Surface Control > Apply Surface Texture and under Using choose Paper. Start with a 100 percent setting for Amount and Picture. Set Reflection to 10 percent and click OK to view the newly textured image.

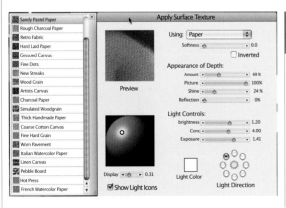

170 Surface texture paper view

Go to Effects > Apply Surface Texture > Using > Paper. With the Apply Surface Texture window open, click on the Paper Selector in the Toolbox. Click on different papers to see their effect live in the Preview window.

171 Surface texture to part of an image

To apply Paper texture to part of the image, use a selection tool to define the area you wish to texturize. Then go to Effects > Apply Surface Texture and under Using choose Paper.

172 Embossing using Original Luminance

With your image open, go to File > Clone. Open the Color palette and select a color. Go to Effects > Fill and click OK. Go to Effects > Surface Texture > Apply Surface Texture and under Using choose Original Luminance.

Applying masks and weaves

173 Create a mask

To quickly create a Mask in Painter, choose any selection tool from the Toolbox and make a selection. Go to Select > Save Selection and in the Save Selection box give it a name. To see the Mask, open the Channels Layer. Click on the eye icon next to its name to see it as a Mask.

174 Weave Fill

In the Toolbox choose the Lasso tool and create a selection. At the bottom of the Toolbox click on the Weave Selector and select a Weave. Go to Effects > Fill > Weave.

Working with text

175 Creating text

Open the Property bar with Window > Show Property Bar and in the Toolbox select the Text tool. Of the three Ts on the left of the Property bar, click on the first on the left and scroll down the list of fonts to choose one. Set the size and color, and apply them to the canvas.

176 Text to Image

To paint on text you will need to convert it to an image layer first. To do this, click on the Text layer to select it. Click on the triangle top right of the Layer palette, and from the menu select Convert to Default Layer. The T icon on the Text Layer will disappear.

177 Text shadow

To quickly add shadow to your text, click on the relevant Text Layer to select it. Go to the Property bar and for External Text click on the third icon from the left. Your text will be automatically shadowed. For internal shadow click on the fourth icon from the left.

178 Shadow color and opacity

To change text shadow color, go to the Property bar and click on the little triangle by the color square to open the color palette. To control text opacity, go to the Property bar, click on the icon next to Color, and adjust the slider for a real-time preview of the effect.

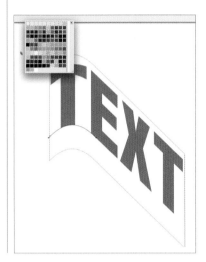
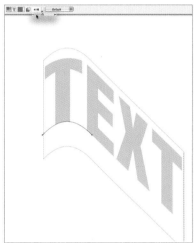

179 Text on Curve

Select the Text tool from the Toolbox. Click on the Text Layer on the Layers palette to select it. Go to Window > Show Text and under Curve Style choose the Curve Ribbon icon, second from left. Move the centering slider to see the text move along the path.

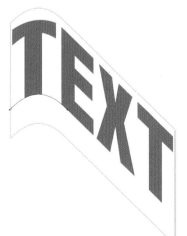

180 Straight-line strokes

To apply straight-line strokes to your image, open the Brush Selector bar and choose Art Pen Brushes > Pen Art Marker. In the Property bar, click on the Straight Line Stroke, third icon from left. On your canvas click once where you want your stroke to begin. Now click where you wish the stroke to end.

181 Brush stroke Align to Path

To align a blending effect to a Path, choose the Pen or Quick Curve in the Toolbox. Create the Path on the canvas and in the Property bar click on the Align to Path icon, fourth from left. From the Brush Selector bar choose a brush of your choice and go over the Path.

182 Marbling

The Marbling effect works best with Patterns, so start by opening Pattern Selector and choosing Decorative Ginko Fill. Select All, go to Effects > Fill > Pattern. Use a selection tool to create a selection within the image. Go to Effects > Esoterica > Apply Marbling, Spacing 50, Wavelength 1.00, Direction Top to Bottom.

Illustrator
Robert Brandt

Adobe Illustrator

has become an industry standard for drawing with vectors. Vectors are resolution independent making them increasingly useful and in demand, especially for web graphics where Illustrator can be used in conjunction with Flash. If you have used any other Adobe software, the Illustrator tools will seem very familiar to you.

Interface

183 New documents

When creating a new document, choose an appropriate page size and orientation, and then open the advanced options. Make sure that you will be working in the correct color mode, for example, CMYK for print and RGB for web, and that the raster effects are at the correct resolution, for example, 300ppi for print, 72 for web.

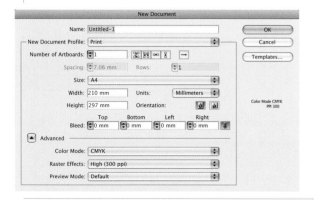

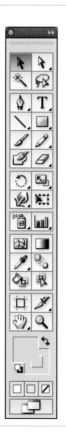

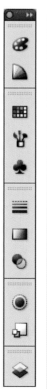

184 Default layout

Initially you'll be presented with a standard layout of tools on the left. On the right you will see the new icon-compressed version of the floating palettes that contain, when you click on them, the main palettes for swatches and tool settings, as well as type options. These can be added to or removed by selecting options from the Window pull-down menu.

185 Creating your own layout

Clicking on the double arrows at the top of the stack will expand all the windows; clicking on one item in the stack will expand just the selection. If you want a window to remain permanently open and in a specific position on the screen, click and drag away the gray bar at the top of the window.

186 Hidden options

Within most of the floating palettes there are additional options. Clicking on the three-line icon in the top right of the palette will give you the chance to view more settings and options.

187 Docking palettes

Palettes can be docked and minimized at the same time by dragging them under and against the column of icons on the right. Just click to expand them again.

188 Hidden tools in the Tool palette

The Tool palette on the left also has hidden options; click and hold on an icon and the "nested" tools underneath will become visible. If you want to keep them exposed, run the cursor over to the bar on the right-hand side of the list and let go.

189 Stroke and fill

At the base of the Tool palette are two overlapping boxes. The solid box represents fill color and the hollow box represents "stroke" (the line color). These are the colors that will be applied when you draw. The box that lies on top is active. Click one to bring it forward. A red stroke through the box means it has no color and will be transparent.

190 The Control bar

Along the top of the screen is the Control bar where there are quick links to some of the more commonly needed tools and parameters. They should save you a little time and screen space if you can become accustomed to using them. The display will change according to what tools you are using.

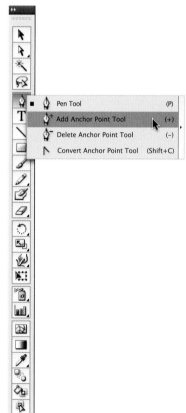

Tools

191 The Pen tool

The Pen tool allows you to make finely controlled lines that will be perfectly straight when you make a series of clicks. To make a rectangle, click to position its four corners, then click on the point where you started and a closed shape will be created.

192 Adding and removing points on a line

To take maximum advantage of drawing with a computer, just as much time is spent "tweaking" as drawing. The tools nested under the pen will help you manipulate lines already drawn. The Delete and Add anchor-point tools allow you to create or remove points on a line.

193 Converting to curves with the Convert Anchor Point tool

The Convert Anchor Point tool will transform a sharp corner point with no handles into a point that defines a curve. These handles control splines. Click and drag one to adjust the shape of the curve with the selection tool. Creating curves with the Pen tool.

194 Creating curves (splines) by click dragging

The Pen tool creates curves when it is used with a click and drag motion. A simple click and a click drag will create an arc; multiple click drags will create a complex curve.

195 Adjusting splines

Once completed, the curve can be adjusted by moving the points or spline handles that appear when a point is selected. To adjust one handle without moving the other, hold down the ALT key.

196 Smoothing curves with the Simplify tool

The Simplify tool under the Objects palette will automatically remove unnecessary anchor points. Its settings give control over how far this process goes, and it can dramatically alter the shape of a path.

197 Selecting objects with the Selection and Direct Selection tools

Once something has been drawn, the selection tools will allow you to pick up a shape or part of a shape and manipulate it. The black arrow Selection Tool at the top of the tool palette will pick up an entire object and anything connected and grouped with it. The white arrow is the Direct Selection tool and will only pick up the clicked part of the object.

198 Selection marquees and the Lasso tool

Both selection tools allow click and drag to create rectangular selection marquees. If an irregular-shaped selection area is needed, the Lasso tool can be used to draw whatever shape and size you need.

199 Geometric shapes (including stars)

The shape tools, nested together under the rectangle tool, create geometric shapes, such as circles and stars. Either click and drag to make a shape, or a simple click will bring up a dialog box that allows manual input of parameters. Some shapes such as stars have specific options like the number of points.

200 Drawing freehand with the Brush and Pencil tools

To draw freehand use the Pencil or Brush tools. Both will allow you to click and drag freehand lines. Illustrator will create the necessary anchor points to represent the lines you draw. Once you have finished a line, you can go back and alter it with the Direct Selection tool.

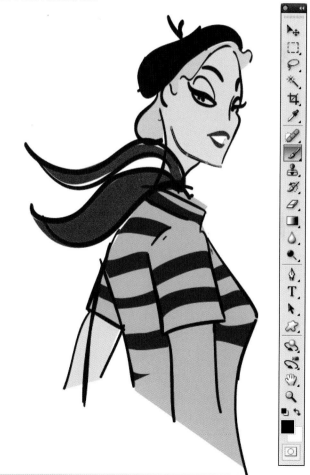

201 Pencil and Brush tool preferences

Double clicking on the Pencil and Brush tools will allow you to view and alter the tool's preferences, and adjust it to suit your drawing style, depending on how smooth you wish the lines to be and whether you wish the line to remain selected after you have finished drawing it.

202 Pencil, Smooth, and Eraser tools

The Pencil tool always produces a simple, plain line, and is perfect for drawing as if you were sketching. Nested underneath it is the Smooth Tool for redistributing anchor points and the Eraser tool for removing sections of the line.

203 The Brush tool

The Brush tool behaves just like the Pencil tool but controls a variety of faux medium effects like calligraphic nibs and broad watercolor brushes, as well as custom patterns. To change the brush, open the Brushes Palette from the Windows pull-down menu. If you don't find what you're looking for there, open one of the additional Brush Libraries at the bottom of the same pull-down menu.

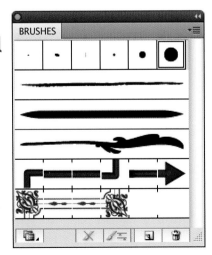

204 Brush style options

Double clicking on the chosen brush style icon in the palette can alter the individual brush behavior. Alter the angle, default width, and shape. If you are using a graphics tablet, this is where to set pressure sensitivity, opening up a new world of possibilities.

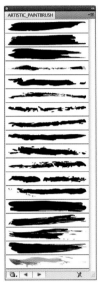

205 The Eraser tool

The Eraser tool is new to Illustrator CS3. It carves away at vector shapes as if with a chisel. Like other drawing tools, a double click will reveal pressure and other settings. Because vector artwork shares so much in common with traditional printmaking techniques, the eraser can be a very powerful and naturalistic tool.

206 Stroke width, corners, and ends

The width of the lines created with the Pen, Brush, and Pencil tools is defined by the stroke-width setting, located in the Stroke Palette. Also in this palette the behavior of the corners and ends of the lines can be defined between rounded, square, chamfered, etc.

Color

207 Fill and Stroke colors

Once an element has been selected, a single click on the Fill or Stroke box at the base of the Tool palette will reveal the color palette. Each of the sliders represents a color channel, and the relationship between their positions will determine the color of the element.

208 Choosing colors with the Color Picker

A double click on the fill or stroke squares at the base of the Tool palette will reveal the Color Picker. This provides another way of selecting colors within a field representing chromatic intensity and lightness.

209 Color books

Very often it is necessary to work with specific colors or with a restricted palette. Go to the Swatch Libraries in the Windows pull-down menu and select either an appropriate range or one of the many Pantone referenced "Color Books." To achieve a gradient, open the Gradient palette in the Windows menu and click anywhere on the gradient bar while the object and fill option are selected. The bar will automatically create a white to black fill; open a color palette, and drag and drop new colors into the arrows at each end, or double click on the sliders to open up color options.

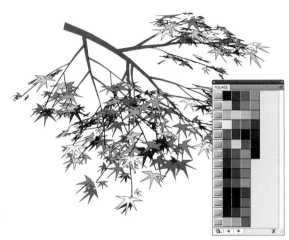

210 Rotating gradients and adding transitions

A gradient transition can be altered by moving the sliders in and out. You can also add additional sliders to the gradient bar by clicking on an empty section. This way it is possible to build up a multicolored graduated fill, such as a sunset, for instance.

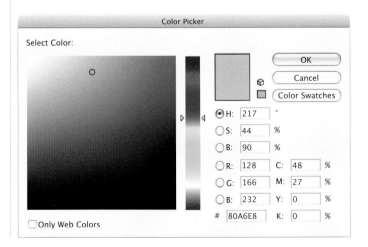

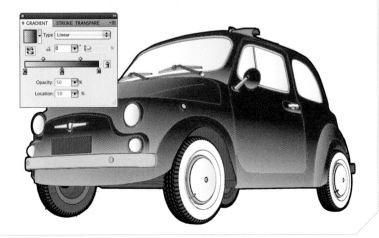

211 The Gradient Mesh

Gradients don't have to be linear or radial. The Gradient Mesh tool allows an uneven grid to be created within a shape where each point can contain a different color that bleeds outwards, blending with adjacent hues. The shape of the grid can be tweaked to adjust the transitions.

212 Applying a Gradient Mesh

Select the Gradient Mesh tool from the Tool palette and click inside a shape. Blue points and splines will be created. Click again in a blank space and another intersecting set of splines and points appear. Open a swatch palette and drag and drop colors onto the points and rectangles between. Use the Direct Selection tool to move the points and spline handles.

213 Pattern swatches

Fills are not limited to color options. Patterns can be created or chosen from a Pattern swatch palette.

214 Color guide panel

Here the colors used in a document generate rows of suggested harmonious colors based on a choice of rules. To change the rules click on the arrow to the right of the top color bar. A selected object or swatch defines the base color. To change it, reselect an element and then click the base color box to the left of the top color bar.

215 Creating patterns

To create patterns of your own, first draw the repeating element and then drag it into the document's swatch palette, which can be found in the Windows pull-down menu if it is not already visible. Now this swatch can be used as a fill for shapes.

216 Live color

The Live Color dialog box allows the editing of Color Guides and can adjust all the colors in a composition at once according to saturation, luminosity, brightness, and temperature. When several objects are selected the color of the element defines the base color.

217 New color group, saving your colors

Once you have settled on a combination of colors, Live Color can save them as a New Color Group to use in a series of illustrations. Click on the folder icon above the Color Groups list. If the list is not visible, click on the gray arrow on the right-hand edge of the Live Color Palette.

219 The Magic Wand

If there are a number of objects in a drawing with the same color and you need to adjust the color in all of them, there is no need to select them all individually. Click on one with the Magic Wand tool and all objects with the same fill will be selected.

218 Altering the colors of the entire document with Live Color

Make sure nothing is locked, Select All, and open Live Color from the Control bar at the top of the window. Click Edit above the color bars and then select Global Adjust by clicking on the arrow to the right of the color sliders at the base of the panel. Adjustments made to the new sliders will affect the whole image.

220 The Eyedropper

Very often on a composition several elements should have the same color and stroke width. Rather than painstakingly setting them all manually, use the Eyedropper tool to click on the object to be copied and then ALT click on the object to be changed. Double click on the Eyedropper tool to access the preferences that decide what attributes will be transferred. The Eyedropper can also pick up color from imported photographs, which is very useful for integrating raster and vector elements.

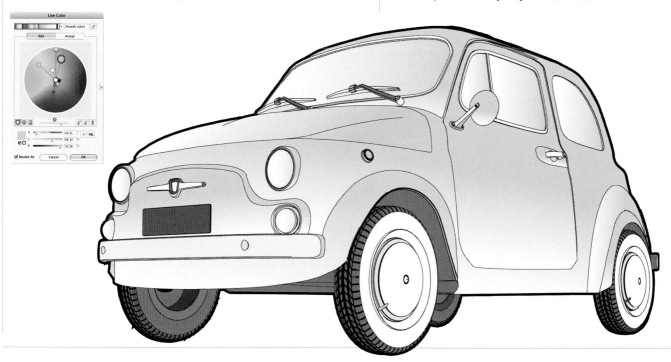

Editing whole objects

221 Using the Pathfinder tool to cut objects with objects

Objects are able to interact with one another when they overlap, and the Pathfinder tool provides options for them to be joined together or cut into one another in a variety of ways. Select two or more objects and click an icon in the Pathfinder palette. The higher object will always cut the lower one(s).

222 Making Pathfinder operations permanent

The Expand button makes the Pathfinder edits permanent and ungroupable. Before it is pressed, the Expand Appearance option in the Object Menu will undo Pathfinder actions.

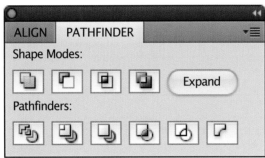

223 Aligning elements

The Align palette allows objects to be arranged in relation to one another with even spacing between them, which is very useful for graphic illustrations or integrated text.

224 Layers

Layers allow a document to be split into groups that lie on top of one another. Use them to avoid having to create awkward groups for selection and transforming. To create a new layer, open the Layers palette and click the three-line icon in the top right corner.

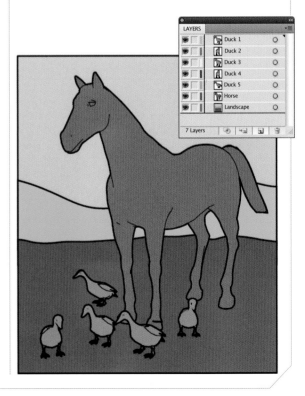

225 Locking layers

To prevent elements in a layer being selected or altered unintentionally, click in the empty gray square to the left of the layer name in the Layers palette. A padlock icon will appear and nothing in that layer can be selected or altered until the same box is unchecked.

226 Hiding and showing layers

The eye icon in the layers list indicates if that layer is visible on the page—click the eye to change from one to the other. The order of the layers in the list is important; the high layers will obscure the lower ones. Click and drag the layers up and down in the Layers palette to alter the stacking order.

227 Rotating and scaling with the Transform command

The Transform command in the Object menu holds a number of tools for manipulating elements that are also available directly with the cursor using the Selection tool. However, here you can enter numeric values for scaling and rotating that can be handy for accuracy or more responsive when dealing with large groups with many anchor points.

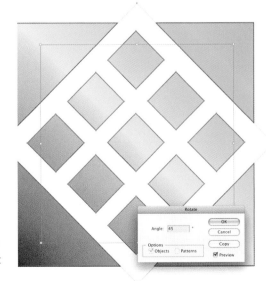

228 Moving objects above and below one another

As an illustration develops, elements will be laid one on top of another even within layers. To change the order in which they are arranged, use the Arrange tool listed in the Objects menu: Send to Back, Send to Front, and the incremental Bring Forward and Send Backward. Learn the shortcuts if possible because you will use these functions a lot.

229 Making elements editable

Frequently it will be necessary to alter the form of uneditable strokes and brush marks so as to widen a line or make it uneven, and add variety to an otherwise mechanical-looking drawing. Use the Expand or Outline path options to make a stroke into an object.

230 Hiding parts of elements

A clipping mask can be used to hide parts of an image, object, or group. Any object with a fill can be used as a mask. Place it over the work to be clipped, resize it, and position it representing the area to be retained. This top object will clip everything selected underneath it when the Clipping Mask > Make tool is selected. The relationship will remain editable and the mask can be removed by the Clipping Mask > Remove command in the same location.

231 Cropping the document

When an illustration has to fit into a specifically proportioned space, rough edges have to be cleaned up. Unlike the Clipping Mask tool, the Crop command is designed to chop the edges of the entire document, rather than just a collection of elements.

232 Types of crop

If a document is cropped without any element selected, the edges of the art board will be used. If a rectangle is selected it will be used, lines representing the crop area will be produced, and when the document is exported or printed everything outside the area will be ignored. The crop marks are used by printers as guides.

233 Using the Crop tool

The Crop tool, new to CS3, allows a marquee to be dragged over the artwork which can be adjusted at any time with the Crop tool selected. Double clicking on the tool icon displays a dialog that can set the crop box to standard dimensions, including paper and screen sizes.

Distorting and warping

234 Filter versus Effect

Flicking through the options in the Filter and Effects pull-down menus, it is clear that several functions are duplicated. It's not an accident. A filter will actually distort the path and its anchor points while an Effect will only alter the appearance of the object, leaving the path in its original position. For this reason, filters are more permanent than effects and can't be edited after you have clicked Apply.

235 Warp

The selection of warp options found under the Effects pull-down menu allow the simple distortion of one or a collection of shapes using a chosen field shape such as wave or flag. They can be very useful when a uniform distortion is needed for several different shapes, or when distorting a drawing that has many elements and anchor points which would be very time-consuming to alter manually.

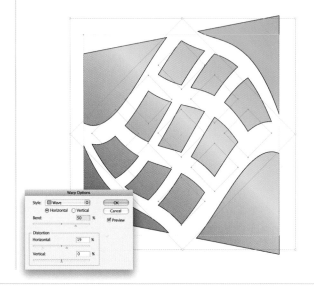

236 Distort (and Transform)

The options under these headings will apply interactive changes to selected elements; where necessary they will create new anchor points, which can be very useful for softening the edges of a drawing, giving it a more hand-drawn look.

237 Free Distort

Free Distort is particularly useful for creating perspective effects in complex shapes such as text. If you are working with a number of objects, group them together for a cohesive result. Move the corners of the delineating rectangle in the Free Distort window to suit your needs and click Apply.

238 Drop shadows and glow with Stylize

To give the effect of an element floating over the page, drop shadows are very useful and can be edited at any stage after they have been created. Inner glows can break up a flat color fill and soften edges without rasterizing the object. The commands are found in the Effects pull-down menu under Stylize.

239 Artistic effects

Illustrator has many of Photoshop's effects; the difference when used via the Effect menu is that the raster effects are applied to vector objects that remain editable. Use them with care. This standard filter can make your work look over-processed.

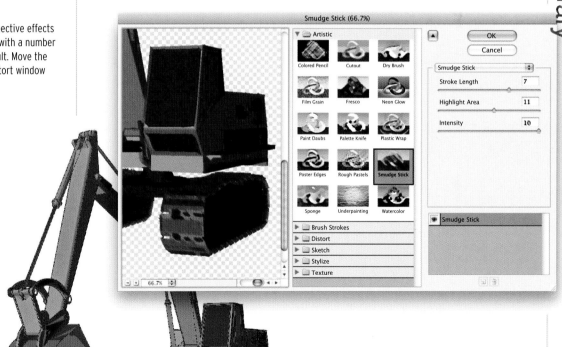

240 Adjusting effects

Select an element and open the Appearance palette via the Windows menu. All effects applied to it will be listed, and here you can alter the order in which they are applied or delete them altogether by dragging them into the palette's wastebasket. Double clicking on a listing will reopen the effect's parameter window.

241 The Distorting tools

The Warp tool and the other distorting tools nested underneath it in the tool palette, push, pull, and tweak shapes, creating anchor points as they need them. Unlike filters, only the areas under the tool are affected.

242 Distortion tool settings

Double clicking on the distortion tools will access a wide range of parameters such as circumference and strength; some of them can also be pressure sensitive if a graphics tablet is being used.

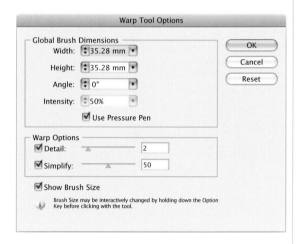

243 Transparency

Unlike in Photoshop, transparency is applied to drawing elements rather than layers. Settings can be found in the Transparency palette that controls the degree and type of transparency. The type chosen will radically alter the effect an element will have on another beneath it, and some startling results can be achieved.

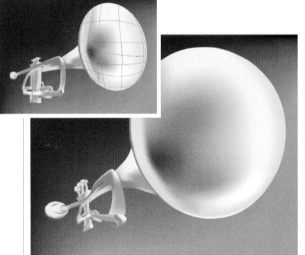

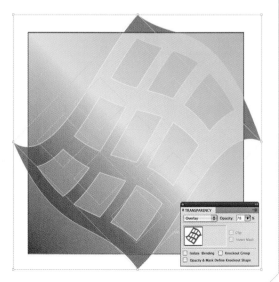

Type

244 The Standard Type tool

The Type tool has several nested alternatives in the Tool palette. The Standard Type tool allows you to simply click on the desired start point in your composition and begin typing.

245 Type box

The Standard Type tool is ideal if you just want to type a line or two. However, if a body of text is to be inserted click and drag with the same tool to create a box. When the mouse button is released a cursor will appear in the top left-hand corner and the text will be restricted to the box.

Lorem ipsum dolor sit amet, consectetuer adipiscing elit. Aenean at quam. Aliquam consequat. Nulla nibh. Etiam sem. Vivamus id mauris id nisi elementum interdum. Praesent aliquet, tortor in vehicula malesuada, mi tellus suscipit sem, sed feugiat nisl velit ut odio. Maecenas porttitor. Donec ipsum. Nulla sem orci, viverra sed, pulvinar in, ultrices aliquet, neque. Nam ultrices quam in sem. Pellentesque ut ligula. Sed sollicitudin est sed risus. Nam metus. Nullam cursus leo id ipsum. Donec eget orci. Donec eget risus in arcu pulvinar tempor. Phasellus interdum rutrum ante. Nulla ut enim quis augue facilisis convallis.

246 Area Type tool—Place type in an object

If type needs to fit into an awkwardly shaped space, draw an object to fit with the Pen tool and then select the Area Type tool nested with the Standard Type tool. Click on the edge of the shape and start typing. The shape becomes a text box and the characters will stay within its boundaries.

247 Type on a path

To get a line of text to follow a path, be it a wavy line or a circle, create the path. Click on it where you wish the text to begin with the Type On Path tool. Once the text has been inserted, use the blue lines either side to adjust its position or flip it to run on the other side of the path.

248 Character palette

The Character palette provides the settings for font, font size, line spacing, kerning, etc. Here you can also stretch text in both directions without turning it into outlines.

249 Turning type into editable objects

In order to change the shape of letters it is necessary to convert them into editable objects. Do this with the Create Outlines command in the Type menu.

Using imported images

250 Importing photographs and scans

A reference image can be placed in the same document as the drawing, to save flicking back and forth and to allow tracing. From the Edit menu choose Place and locate the image file. The image will appear at its native resolution in the document and can be scaled just like any other object. Put it in its own layer and lock it to avoid accidental selection and easy hiding.

251 Automatic tracing with Live Trace

Live Trace automates the process of tracing imported images, and is particularly useful for digitizing scanned sketches so that they can be colored and adjusted as vector files.

252 Starting Live Trace

Place an image in the Illustrator document. While it is selected the Control bar at the top of the screen displays options for dealing with the image. Click on Live Trace and the image will be converted into a preview of the vector version. If you are happy with the image immediately, click on Expand and the object becomes editable with the normal tools.

253 Live Trace presets and options

If the results of the default tracing presets are not adequate, either choose another preset from the control panel or click on the tracing options button next to the preset options. The presets define the type of tracing resulting from posterized colors to monochrome.

254 Defining borders with Threshold

Threshold defines where the divisions between light and dark or different colors are made. The minimum area defines how large an area of color must be before a vector shape is generated.

255 Refining the trace with Blur

The Blur option actually blurs the original image to create smoother and more natural lines in the trace. Adjust it in very small increments. Select Preview to see the results of your settings before closing the window.

256 Managing trace detail

The various trace settings on the right of the Trace preferences define the amount of detail in the trace; a highly detailed trace can create a very large and unmanageable file.

257 Coloring with Live Paint

Live Paint automates the process of filling areas defined by perimeter lines with color, removing the need for drawing solid shapes in order to render a drawing. Combined with Live Trace it becomes a powerful and time-saving tool. There is a button in the Control bar of Live Trace that allows direct transition to Live Paint options.

258 Creating a Live Paint group

Select the objects that are to become a Live Paint group, and choose Live Paint and then Make from the Object pull-down menu. A bounding box with distinctive corner points will show the group.

259 The Live Paint tool

Make sure the Live Paint tool is not selected. Choose the Live Paint tool from the Tool palette and as the cursor runs over the Live Paint group, areas that have been given a fill that can be colored will be highlighted. Click to apply a color.

260 Choosing Live Paint colors

To change the color the Live Paint tool carries, click on a new swatch or use the arrow keys to scroll back and forth along the selected swatch collection. The boxes above the cursor show current color and the colors left and right of it in the listing.

261 Dealing with gaps in Live Paint mode

Very often an area that needs a fill is not entirely enclosed by lines. To avoid having to adjust the line, open the Live Paint Gap Options to the right of the Expand button in the Control bar. Switch Gap Detection on and choose small, medium, or large gaps depending on how sensitive the detection needs to be.

Flash

Jim McCall

Adobe Flash

consolidated its position in the web design industry when it was bought by Adobe. If you're an illustrator working with websites, this is the program you should learn first. It's not just for animation, its vector drawing tools work just as well for still illustrations, and whatever you do with it you know it is going to be web safe.

Workspace and palettes

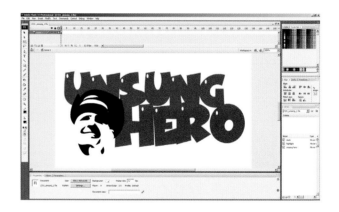

262 Palettes

Palettes can be opened or closed from the Window menu. It's easier just to show the palettes you need, giving you more space to work. You can also save your preferred workspace layout by choosing Windows > Workspace > Save Current.

263 Color palette

It is also useful to set up a palette of colors for use in your document. The default palette is the web-safe palette of 216 colors. You can add colors to the current color palette using the Color Mixer.

Planning, preparing, and design

Storyboarding

264 Setting up your canvas

Before starting work on your illustration, set up your canvas size and background color. It is good to establish this at the beginning of the project, as resizing objects or areas later can cause problems.

265 Frame rate

If your project is to be animated, you need to specify a frame rate. Flash's default frame rate is 12 frames per second (fps). A smoother action can be achieved by increasing this to 24fps. Be aware that the higher the frame rate and the larger the canvas size, the more processing power, or CPU, the movie will require.

266 To scale or not to scale

Flash movies can be designed to scale to fit a viewer's screen resolution or to be fixed. You should decide which option to take before starting work as each can determine the style of illustration.

267 Fixing the scale of your illustration

If you don't want your illustration to scale, then you can use ActionScript to fix it. Make a new layer in the timeline and call it "Actions." Click on the first frame of the new layer. Open the action panel and enter the following:

fscommand("allowscale", "false")

268 Storyboard

It can be useful to plan your document on paper first. If you're going to create an animation, a storyboard can be especially handy.

269 Tracing

It can often be easier to start a project on paper. Then, when you have the basic shapes, scan and import your drawing into Flash. Place the scan on the bottom layer in the timeline and make the layer a "guide." This can then be traced using the drawing tools. Guide layers do not affect the document file size and are not visible when published.

Navigation: symbols, buttons, and menus

270 Symbols

A symbol is an object created in Flash that can be reused throughout your movie. There are three types of symbols: Graphics, Buttons, and MovieClips.

271 Importance of using symbols

Using symbols is crucial to the file size of your document. A symbol's size is taken into consideration only once even if it is used 100 times.

272 Buttons

Button symbols are used for timeline navigation. They add interactivity to the movie and respond to mouse clicks, key press or rollovers/rollout, and other actions.

273 Using MovieClips

Where possible, make any items that are not buttons MovieClip symbols. You can then control them from ActionScript to do things such as change their dimensions, position, color, alpha (the transparency of an object or color fill), and other properties.

274 Symbol Instance

A copy of a symbol used in the movie is called an Instance, which can have its own independent properties such as color, size, function, etc.

275 Editing symbols

Always remember that when a symbol is edited, all of its Instances get updated. However, changing the properties, effects, or dimensions of a symbol's Instance does not affect the original or other Instances.

276 Naming symbols

Prefixing the different types of symbols can help when organizing the document's assets.

277 Navigation layout

When creating a navigation layout, it is often easier to layout all the elements first. Then, when you are happy with the design start converting the elements into symbols.

278 Button states

"Up" is how the button looks in the default mode. "Over" is how the button looks when a mouse is rolled over it. "Down" is how it looks when the mouse is clicked. You must also define a Hit area, which is the area of the document that the mouse must move over to activate the button (usually over the button graphic itself).

Layers

279 Layers

Layers are very useful in Flash as they allow you to organize your document, and to define the movement of items. Use as many layers as you need to keep everything separate and structured.

280 Layers (continued)

When two objects are sitting on top of one another, you can switch off the visibility of the top layer so the object underneath can be seen. Visibility does not affect the published movie.

281 Layer naming

Be consistent in the way you order and name layers so that if you have to leave a job and come back to it later, you won't be totally lost. Name layers with meaningful titles that you will be able to identify easily, such as "main logo" or "home button."

Color

282 Color Swatches

Use the Color Mixer panel to select a color. Then add it to the color swatch list for the current document by selecting Add Swatch from the pop-up menu in the upper right corner of the Color Mixer.

283 Working with colors from other applications

To ensure consistency when collaborating with others, you can import and export both solid and gradient color palettes between Flash files, as well as between Flash and other applications, such as Adobe Photoshop. You can also import color palettes, but not gradients, from GIF files.

284 Sorting colors by hue

To make it easier to organize your color palette, you can sort the colors by Hue. To do this, select Sort by Color from the pop-up menu in the upper right corner of the Color Swatches panel.

285 Replacing a color

You can replace a color in your document by going to Edit > Find and Replace, then select Color from the drop-down menu. You can then select the color you wish to change and the color you want to change it to. You can also select color in this way for strokes, fills, or both.

Drawing techniques

286 Starting off

When creating an illustration it can be a good idea to start with "primary" shapes such as lines, circles, and squares. Lines and intersections can then be modified to form the required shape.

287 Modifying shapes

To modify lines, intersections, and fills, move the Select tool so it is over an unselected piece of stroke or the edge of a fill until the cursor changes. It can then be used to click and drag that piece of stroke or fill into a new shape.

288 Modifying shapes (continued)

When the select tool is over a piece of stroke or the edge of a fill until the cursor changes, ctrl-click-and-dragging (Mac: option-click-and-dragging) will add a new anchor point to that edge.

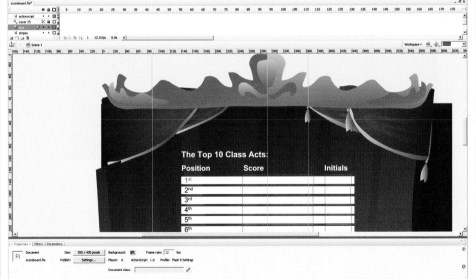

289 Editing strokes

If a piece of stroke is drawn, copied, or dragged so that it intersects with other strokes, the pieces of stroke between and outside the intersections will be individually editable. They will also divide up the previous area into a new, individually editable shape.

290 Editing shapes

If a fill shape is placed so that it overlaps a portion of another shape in the same layer, it will erase the overlapped portion once it has been deselected. This can be useful for cutting shapes out of the middle or edges of other shapes. To keep this from happening, make the shapes on different layers.

Drawing tools

293 Tools

The Tools panel contains Flash's drawing and transformation tools. It also contains additional settings for some of the tools. When you click the arrow, the icons Lasso, Rectangle, Pencil, Brush, Free Transform, Paint Bucket, Eraser, or Zoom tool appear in the Options area of the toolbox. You should also notice that many of these tools have additional settings in the Property Inspector.

291 Masks

Masks are an important tool in creating cool images and animations. You can use Alpha gradients within masks by caching both the mask and item to be masked as a bitmap.

294 Drawing with the Pencil tool

The Pencil tool has three options for drawing a stroke freehand: ink, straight, and smooth. Experiment with these settings to find the best one for the type of drawing you are developing.

292 Double lines

It is useful to be able to add a double line around an object. To do this, turn the shape with a single line around it into a MovieClip, then add a drop-shadow filter. In the filter settings, increase the Strength to 1,000 percent and the Distance to 0. Choose the color you want the line to be, then increase the Blur settings until the line is the width you require. This is especially effective on complex shapes like Text.

295 Pen tool

The Pen tool is one of the most useful tools when drawing in Flash. A single click on the mouse will add an anchor point and line. If you click and hold the mouse button, the line can be curved.

298 Gradient transform

Gradients can be edited when in place using the Gradient Transform tool. Clicking and holding the Free Transform tool icon will bring up this option. Once selected, click on the gradient you wish to modify and use the handles to change the parameters.

296 Stroke objects

The Pencil, Ink Bottle, Line, and Pen tools create stroke objects. The Pen tool will also create a fill object if it is used to make a closed shape.

297 Fill objects

The Paint Bucket tool is used to create a filled area within a predefined stroke. The Oval and Rectangle tools can be used to produce strokes, fills, or both, depending on how the stroke color and fill color boxes are set.

299 Hairline strokes

If you want to create an outline that will not become thicker or thinner as the shape is resized, you should use the hairline option. All of the other stroke styles will appear thicker as the entire outline is resized.

300 Keyboard shortcuts

As you become more experienced using Flash, you might find it useful to employ keyboard shortcuts to switch between the drawing tools. For example, after you've drawn a rectangle, you can press the O key to draw an oval.

Vectors and pixels

301 Rectangle and oval Primitive tools

These tools allow you to fine-tune the standard rectangle and oval shapes by adding things like beveled corners, start and end angles, and an inner radius.

303 Style

In Flash, the basic format used is vector graphics. However, bitmaps can also be used within projects. Often a mix of both is used to develop effective illustrations. The main difference is that vector data can be scaled with no loss of quality whereas bitmap data will become pixelated if scaled up, or rough and undefined when reduced.

302 Poly Star tool

To make more complex shapes use the Poly Star tool. This can be found by clicking and holding the Rectangle tool icon. Once selected, clicking the Options button in the Properties panel can access further parameters.

304 Vector shapes

Anything drawn in Flash is a vector graphic. A shape on the stage can be made up of a stroke object, a fill object, or combinations of the two, and it can be resized without losing resolution.

305 Making symbols in other applications

As well as generating symbols that originate in Flash, we can also include artwork that is imported from another application. In general, it is better to import bitmap objects as PNG files where possible.

306 Trace Bitmap

Flash has the facility to convert a bitmap object to a vector graphic by "tracing" the shapes. This technique can generate some interesting results! All parameters are controlled from the Trace Bitmap dialog box.

Text

307 Adding legible text

Achieving crisp text within Flash is a lot easier in the recent versions of the program. When you create text, select one of the options from the drop-down menu in the Properties panel such as Anti-alias for Readability.

308 Text as graphics

If you are using text as graphic elements within an illustration, rather than copy what is to be read, it is often useful to change the item into a shape and then convert it into a Symbol.

309 Embedding fonts

If you want the text in your document to look dynamic (such as read from a database), you need to make sure you embed the font in the document. To do this, select the Dynamic text field, make sure you have selected the correct font, then click on the Embed button to the right of the Anti-alias drop-down menu.

310 Customizing text

To change the tracking or kerning of text, use the letter-spacing slider in the Text Properties panel. The orientation and rotation of text can also be set in this panel. Further options such as line spacing and margins can be found in the Edit Format Options panel.

Links

311 Adding links to a button symbol

First locate the button symbol to which you want to add a link. Then open the Actions panel and add the following ActionScript:

```
on (release) {
        getURL("your_url_here");
}
```

312 Adding links to text

Adding links to text is easy. Simply select the section of text you want to use as a link, then add the URL into the URL link box in the Properties panel.

Animation

313 Animation options

There are several methods to create animations in Flash, such as tweening using the timeline and canvas, or using ActionScript and developing the animation programmatically.

314 Tweening

Tweening is short for "in-betweening" and is the process of creating additional frames between two images to give the appearance of smooth animation. The two images, or the start and end points of the animation, are known as Keyframes.

Creating a motion tween

315 Step 1

Create a small circle to the left of the Stage area. Select the Arrow tool from the left toolbar and double click on the circle to select it. Convert the circle to a MovieClip, name the symbol "Circle," and select OK.

316 Step 2

Insert a Keyframe on Frame 10 in the Timeline. Do this by right clicking the gray field below 10 and then choose Insert Keyframe. Select the circle and move it to the right of the stage.

317 Step 3

Click on the Timeline any place between Frame 1 and Frame 10. Then right click and choose Create Motion Tween. Finally, test your Flash movie to see your tweened animation.

318 Moving multiple frames

It can sometimes be necessary to move an animation that takes place over a number of frames. To do this, click on the Edit Multiple Frames icon below the timeline, then drag the Onion Skin Start and End markers to the duration of the animation you wish to edit. Right click on the stage and choose Select All, then move the items as required.

319 Using ActionScript for animation

Where possible, ActionScript should be used for animation, as it both reduces file size and CPU usage. It can also result in a smoother, more professional-looking animation.

320 Tween class

The Tween class lets you use ActionScript to move, resize, and fade movie clips. The Tween class also lets you specify a variety of easing methods. Easing refers to gradual acceleration or deceleration during an animation, which helps your animations to appear more realistic.

Expand your mind with Your Magic

Sound and video

321 Using sounds

There are several ways to use sound in Flash. You can loop sounds to play continuously, independent of the timeline, or synchronize your sounds to an animation. You can import and edit your sounds in the Sound Panel.

322 Importing Sounds

Import sounds into Flash by choosing Import to Library from the File menu. The following audio file formats can be imported into Flash: WAV, AIFF, and MP3.

323 Sounds in the Library

Flash stores audio files in the Library as a symbol along with the graphics, movies, and buttons. Sound files are indicated by a loudspeaker icon. Because the sound is a symbol, you only need one copy of it and you can use it as many times as you like within your movie. In the Library and on the Timeline, audio files are represented as sound waves.

324 Event sounds

Event sounds must download completely before they start playing, and they will continue playing until explicitly stopped (usually by a stop action). Event sounds are associated with an event such as a mouse click, and are independent of the Timeline.

325 Stream sounds

Stream sounds begin playing as soon as there's enough data to play. These sounds are synchronized to the timeline. Flash forces the animation to keep in sync with the sound. If it can't draw frames fast enough, Flash will drop frames to keep the sound in sync.

326 Using video

Video can be used to great effect in Flash animations. It can simply add background texture or be an integral part of the document. Be careful when choosing video as the file size can quickly become large.

327 Blend modes and video

Flash has a number of Blend modes that can be applied to a video to help place it into a document. In order to use these blends, the video component must be converted to a MovieClip Symbol.

329 Video and tweened animation

Combining tweened animation with video can produce excellent results without having to resort to large video files. When video assets are converted into MovieClips, they can then be tweened themselves. A good example of this is using a short video of a man taking a step, then tweening this clip across the stage to give the impression that the man is actually walking across the screen.

328 Masks and video

Good results can be obtained when using a mask with video. Video content can be played within shapes such as typography or other illustrations.

Interactivity

330 Creating interactivity

To create interactivity with Flash you use ActionScript, which is simply
a set of instructions that define an event, a target, and an action.

331 Simple ActionScript

Here is a very simple way of using ActionScript on a button
to hide another MovieClip Symbol on the stage. First, open
a new Flash document and create both a Button and a
MovieClip symbol.

332 Simple ActionScript (continued)

Select the MovieClip symbol and in the Properties panel give
it the Instance name "my_MC". Now select the button, open the
actions panel, and type:

```
on (release) {
        my_MC._visible = false;
}
```

Test the movie and click on
the button you have made. The
movie clip should disappear as
if by magic!

333 Separate your code

In Flash you can put your code on Buttons or within any MovieClip on the stage.
It is better however to try to keep all your code within an "Actions" layer on the main
timeline. You are then using "Functions" to tell your movie what you want it to do.

334 Example of a function

Here is a very simple example of a function to make a button open a URL, in which
"myButton" is the instance name of your button on the Stage. The below ActionScript
would go in a keyframe on the Actions layer of the main timeline:

```
_root.myButton.onPress = function() {
        GetURL("http://www.theunit.com");
}
```

335 Have a naming standard

Get used to giving your ActionScript objects and functions sensible and easily-
understood names. This will help you to understand the code, and will be highly
appreciated if you need to pass your project to another developer at a later date!

Filters and Compositing

336 Filters

Flash has a set of filters that let you add effects to text, buttons, and movie clips. Filters can also be animated using motion tweens. Filters are accessed from the filter tab on the Properties panel.

337 Compositing

Compositing is used to vary the interaction between two or more overlapping objects. You can use Flash blending modes to overlay objects to let details from an underlying image show through, or to add color to a desaturated image.

338 Filters and Flash Player performance

Beware when using filters. Too many can cause slow playback of your movie. It's also a good idea to disable the Zoom menu options in the SWF file through the Publish Settings panel.

Publishing

339 Publishing your document

To publish your Flash document, you can either press Shift + F12 or go to File > Publish. The Publish Settings can be changed depending on the deployment of your movie.

340 Publish Settings

The Publish Settings dialog box allows you to specify which version of Flash Player the document will require to run, if a HTML document is created, and if other formats such as Windows Projector or QuickTime Movies are published.

341 Publish Settings (continued)

The Publish Settings panel can also be used to select which version of ActionScript is to be employed, and the format and quality of any audio within the movie.

Cinema 4D

Robert Brandt

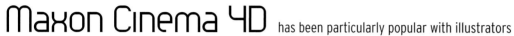

Maxon Cinema 4D has been particularly popular with illustrators

for some years, it is relatively easy to learn and is modular, so you only have to buy the parts you need.

The software is very stable and highly compatible with 2D packages. A finished image can be produced within

Cinema 4D or imported into another program to be incorporated with other techniques.

Interface

342 Viewports

Don't get stuck working just in one view. Get used to toggling between having one big window and four smaller views from different angles. Use the screen icon in the top right corner of the view panel to maximize and minimize the image.

343 Tear-off menus

You can move all the windows in the user interface around. Click and drag the panel title to a new location. You may have a specific repetitive task to perform, or a special way of working that could benefit from your own customized layout.

344 Layers

Use layers to organize groups of objects in order to avoid having painstakingly to zoom in and search for just the right place to click and select a deeply buried object. Open your Layer Browser from the Windows drop-down menu, create new layers, and drag your objects from the Object Manager in the layers of your choice. Hide and show layers by clicking on the eye icon to the right of the layer name.

345 Object Manager

The Object Manager lists all the elements used in a scene including lights, cameras, and special objects like Deformers. Interactions between elements are achieved by placing one element inside another as a "child;" "children" are inset from the left margin to show their status. In the Attribute Manager, drag and drop an object on top of another. The dropped object becomes a child of the other "parent" object.

346 Tags

Many qualities assigned to an object are represented in the Object Manager by tags, which may be materials or instructions for special visibility. A very common tag is the Phong, which smoothes the appearance of adjacent polygons.

347 Content browser

Many time-saving and useful presets are hidden away in the Content browser. Open it using the Windows menu. Here you will find a good selection of materials such as glass, wood, and marble, and standard lighting set-ups, which can save a lot of fiddling around.

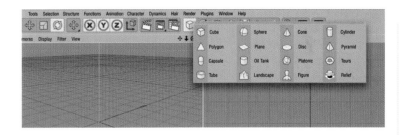

Modeling

348 Primitives

The easiest way to begin modeling is to start with a Primitive object, like a cube or a sphere. Select a shape from the cube icon at the top of the screen and it will appear in your viewport.

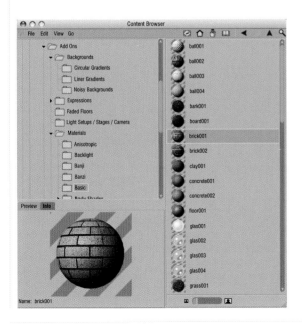

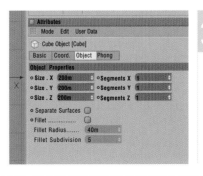

349 Attribute Manager

The Attribute Manager can alter a Primitive object's size (in the Object tab), or you can push and pull the orange toggles that emanate from the object's axis. They are only visible when the object is selected.

350 Making an object editable

Once you have got to the stage where you want to do more than just change the proportions of the shape, you will have to make it "editable." Before you do this, it's often useful to subdivide your shape into sections under Object Properties in the Attributes Manager to increase the number of segments. Now, use the Make Editable button near the top left corner of your screen. From this point you'll be able to use the myriad of modeling tools available in Cinema 4D.

351 Selection options

You can either select the lines (edges), points, or polygons that make up an editable object. To do this, use the appropriate tool from the left-hand side of your display. Once selected, you can use the colored axis display to move or rotate the element around the virtual space. It will take connected elements with it and in this way you can start to create more interesting shapes using Point, Edge, and Polygon tools.

352 Knife tool

As your shapes become increasingly complex, you will want to make more divisions to allow finer sculpting. Use the Knife tool in the Structure Menu. Click and drag across one or more polygons on a selected object, and a new division will be created. Use the options in the Attributes Manager to make sure your cut(s) is/are no more or less than you intended. It's easy to divide a hidden polygon accidentally.

353 HyperNURBS

If you divide an object enough, it is possible to create the illusion of a smooth, organic shape. However, the more polygons your object uses, the more memory it takes up and the more time-consuming it is to create. HyperNURBS automatically smoothes your object's corners, and allows you to make smooth shapes quickly and easily.

354 Creating a HyperNURBS object

Select a HyperNURBS object from the Command palette at the top of the screen and it will appear in the Objects Manager. Drop your object on top of the HyperNURBS icon and it will appear as a "child" underneath. Your object should now look smooth but you can continue to manipulate it.

355 Adjusting a HyperNURBS object

To sharpen corners in a HyperNURBS object, you can either make smaller polygons in the areas of concern or you can use the Weight HyperNURBS tool. Once you have selected the lines, points, or polygons you wish to alter, choose the Weight HyperNURBS tool from the Structure menu, then click and drag anywhere on the active viewport. Dragging to the right increases the sharpness of the selection. Alternatively you can use the slider in the Attribute manager.

356 Selecting elements

There are several tools for selecting elements. Using the right one can save a lot of time. The standard tool will select the single element directly underneath the cursor. The live selection tool selects as you click and drag over an area.

357 Soft selection

When creating smooth shapes, selecting individual points to sculpt flowing curves can be very time-consuming. Try the Soft Selection option in the Attributes Manager of your selection tool. Once on, you can adjust its width and strength. Clicking on a point will show a yellow area of influence, strongest near the point and gradually getting weaker at the edges. When you move the point, surrounding points will move with it according to your settings.

358 Connecting polygons

The first stage when combining two objects into one is to use the Connect function. Select the objects to be joined and choose Connect from the Structure menu. The polygons don't have to be touching. A new object will be created on top of the originals, which you can now delete or move away. However, this is only the first stage in truly joining polygons to create a single geometry.

360 The axis

Every object has an axis that can be moved and rotated. Initially it is placed at the center of the object, but you may want to move it if, for instance, you wish to rotate a tree from the base rather than from halfway up the trunk. To do this, click on the Object Axis tool. In this mode the normal Move and Rotate tools only affect the axis, without moving the object. Once the object has been repositioned, you can click back on the Model tool to continue modeling.

359 The Bridge tool

Two objects that stand apart but have been connected can be joined with the Bridge tool, which will create a new set of polygons smoothly joining the two bodies. Once this is done, HyperNURBS can create a smooth flow of curves over the entire object. Using the Polygon selection tool, choose two facing polygons you wish to join, select the Bridge tool from the structure menu, and click and drag from one adjacent corner to another. A bridge will be created seamlessly spanning the gap.

Fine-tuning

361 The Brush tool

The Brush tool is another way of making smooth sculpting changes in either Point, Edge, or Polygon mode. The brush, which you will find in the Structure menu, can pull, lift, or smear areas of a selected object as you click and drag across it. Adjust the Fall-Off and Mode in the Attributes Manager to get the effect you are after, and the size and strength to suit. Try the Magnet tool as an alternative.

362 The Iron tool

The Iron tool can help you smooth exaggerated peaks and troughs on a surface after you have gone a little too far with other tools. Click near the center of the viewport and drag. All the points of the object will begin to "normalize" as you move to the right. Successive sweeps will enhance the effect.

363 The Close Polygon Hole tool

Naturally it's easy to delete a polygon, point, or edge. Just use the Delete key. But what if you want to put one back or fill a hole among other polygons? Select the Close Polygon Hole tool from the Structure menu and run your cursor over the edge of the hole. When it's highlighted, click and watch as the hole is filled.

364 The Slide tool

When fine-tuning your point positions, use the Slide tool to move points along edges. This will help prevent a point from moving in an undesirable direction and keep the form of your object flowing. Later on, when you come to apply materials and render your scene, an even spacing of points will be very advantageous.

365 Making protrusions with Extrude and Bevel tools

If you need to create protrusions from an object, you don't have to stretch existing polygons. Instead, make new ones with the Extrude or Bevel tools. Select a polygon, then click and drag away from it to extrude a new connected shape. This is a great device for adding limbs to a body.

Splines

366 Splines, NURBS, and extruding

You can create your own shapes from primitives called splines. Draw an object freehand or use a predefined shape. You can't render the spline to make a 3D shape until it's been extruded. Do this by creating an Extrude NURBS object and placing your spline into it in the Objects Manager.

367 Altering the depth of an extrusion

Adjust the depth of your shape by increasing the movement value in the Attributes Manager of the Extrude NURBS object. You can make the object shear off in two directions by entering values in more than one field.

368 Rounded edges

To give an extruded shape rounded edges, select the Caps tab in the Extrude NURBS Attributes Manager. In the pull-down menu within the Start and End fields select "Fillet Cap." Adjust the radius and increase the Steps value to create a curve.

369 Editing splines

Once you have drawn or created a spline, you can use the Edit Spline functions in the Structure menu to manipulate its shape. Remember that you will have to be in Point mode for this kind of work.

370 3D Text

To make 3D text, select the text spline object and type
in your desired words in the text field of the spline's Attributes
Manager, choose a font and adjust the size
in the same window.

371 Loft NURBS

A powerful alternative to extruding splines is using Loft NURBS. Create three splines
with an equal number of points, then drop them into a Loft NURBS object in the Object
Manager and a skin will be created between them. This is a perfect device for boat
hulls, airplane wings, and leaves.

372 Lathe NURBS

If you want to make a shape like a vase or chess pawn, the Lathe NURBS object is ideal.
Draw half the profile of the shape with the spline tool of your choice, create a Loft Nurbs
object, and drop the spline into it in the Object Manager. Move the axis of the Lathe object
to adjust the shape.

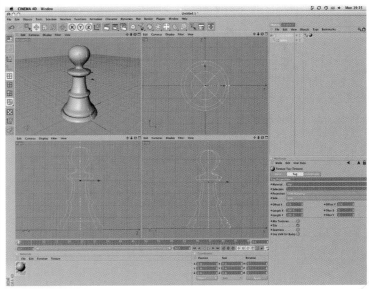

373 Sweeping

If you want to make something like a wavy pipe or a spring, use the Sweep NURBS tool. You'll need a profile spline. Let's now take a circle and a path spline, and use a helix.

374 Creating a circle and a helix

Use the Attributes Manager for the circle to reduce its radius to something very much smaller than the helix. While in that window, check that the plane is set to XY. Check Select a Sweep NURBS object and drop the two splines into it in the Object Manager, making sure that the path (helix) is under the profile (circle).

375 Adjusting the helix

Now you can use the parameters in the helix attributes window to adjust the helix to make the rotation conical, by reducing the end angle. You can increase the number of turns by increasing the end angle, and increase its length by altering the height. Use the attributes of the SweepNurbs object to change the diameter of the circle from one end to another.

376 Importing vector files

The spline tools within Cinema 4D do not always suffice when making complex extruded shapes, such as logo forms. You can import paths from Photoshop or EPS files from Illustrator by opening the files just as you would a normal C4D document.

377 Creating one object from separate elements

Imported documents containing words, for instance, will treat each letter shape as a separate object. Before extruding, save time by connecting them into one shape. Select all the splines in the Object Manager and select Connect from the Object tab in the same window. A new, single object will be created and the old separate object can be deleted.

378 Importing paths from Photoshop

If you have imported a path from Adobe Photoshop, the splines may not have the straight lines and sharp corners you are looking for. This is because during the tracing of the shapes in Photoshop, pixelation will have created slight inaccuracies. In C4D these will be represented by unnecessary points on the spline that can be deleted or edited.

379 Editing points on splines

To work on an individual point, select the Point tool and click on the spline. The points will become visible and another click on one of them will select it. If you want to remove it, just press Delete. If you want to move the point, use the normal Move tool, but if you want to edit the point's features go to the Structure pull-down menu and look under Edit Spline.

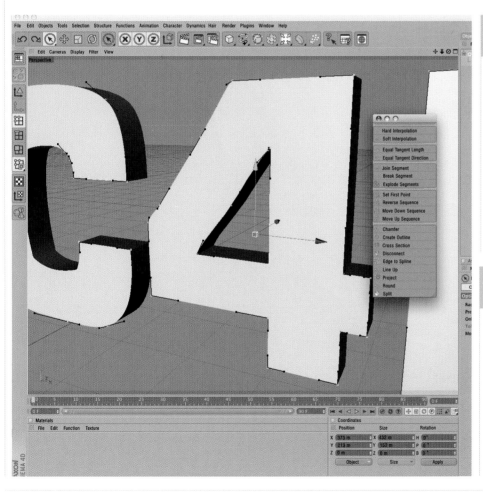

380 Smoothing curves in splines

To smooth the point, select soft interpolation. Handles will be created and by manipulating them the curve of the spline either side can be altered. Holding down the Shift key will allow you to move just one handle (of a pair) independently of the other.

381 Sharpening corners in splines

Unwanted curvy corners are a common problem with imported splines. To sharpen a corner use the hard interpolation tool.

Deformers

382 Deformers

Deformers are shaped fields used to dynamically alter the shape of the object in specific ways. They must be placed as "children" of an object in order to affect it (see tip 345). To do this, choose a deformer and drop its icon in the Object Manager on top of the object you wish to alter. It will appear underneath as a "child" in the hierarchy.

383 Preparing an object for deformation

When using deformers remember that an object can only deform around its divisions. It doesn't matter whether it has been made editable or not. Use the Subdivide command or Knife tool to divide an editable object, or use the Segments field in the Attributes window for a Primitive object.

384 Editing deformers

You can move, scale (uniformly or in one direction), and rotate deformers like ordinary objects.

385 Bend deformers

Use the Bend deformer to turn a cylinder into a semicircular handle or make a skyscraper bend in the wind. Create a cylinder and give it 20 height segments. Then create the Bend deformer and place it in the cylinder in the Objects Manager. Click and drag the orange handle in any of the viewports to see and increase or decrease the image.

386 Deformer influence

By default the deformers are set to Limited mode. This means that their influence is diminished further away from the defined field, creating a smooth but nonuniform deformation. In the Deformers Attributes window try setting the Mode to unlimited. The whole object will now be affected uniformly.

389 Combining deformers

Deformers can be combined. Drop several of them into an object for sophisticated effects. This can save a lot of difficult and time-consuming modeling time.

390 Combining Taper, Twist, and Melt deformers

To make a blob of whipped cream, create a subdivided cube and Slip it into a hyperNURBS object to soften it. Apply a Taper deformer to narrow it at the top, a Twist deformer to create a spiral, and a Melt deformer to soften the peak and add subtle variation.

387 Twist deformer

Use the Twist deformer to create screw effects, though you won't have much luck with a cylinder—use a rectangle instead. Its edges provide the steep angles necessary for a pronounced screw effect.

388 Melt deformer

The Melt deformer differs from the other tools in the deformer family in that it doesn't have a box designating its influence; instead it has an origin. Place it at the base level of the melt effect. Alter its area manually in the radius field and its degree of melt in the strength field. The Randomness fields are useful for attaining a natural, nonuniform look.

Booles and symmetry

 ## Boolean modeling

In Boolean modeling you can use one object as a tool to sculpt another or combine two objects into one. Create a boole and drag two objects into it in the Objects Manager. Their hierarchical order as "children" of the boole will define how they interact. Generally the object above will be cut by the one below.

392 Subtracting, adding, and intersecting booles

Use the Boolean Type pull-down menu in the Boole's Attributes Manager to choose whether one object is subtracted from another or combined with it. The Intersect option will leave you with just the area where the objects overlap.

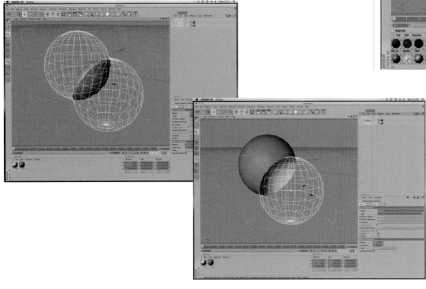

393 Symmetry

If you are modeling a face or a car, there is no need to make each side individually. Use the Symmetry command to duplicate your efforts across the axis. Not only will this save enormous amounts of time but will also ensure that both sides match exactly.

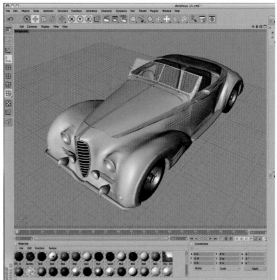

394 Setting up a symmetry object

To make a symmetry object, you will need to place an object. For example, take a Primitive cube on the world axis—this is where newly created objects appear at position x=0, y+0, and z=0. Split the cube into segments making sure that there is an even number on the x plane. It is important to have a seam down the middle of a Symmetry Object.

395 Making a Symmetry Object

Make the object editable and with the Polygon Selection tool delete the half of the cube to one side of the x axis. Now create a symmetry object and drop the half cube into it. The deleted part will reappear but as a reflected copy of the original. Now when you tweak one side the effects will be seen on the other as well.

396 Getting the right Mirror Plane

If you don't see a reflected copy, check that the symmetry object is operating on the right plane in the Attributes Manager. Usually you will want it set to XY.

397 Smoothing across a symmetry seam

Use the Tolerance field in the Symmetry object's Attributes Manager to alter the way the two halves interact. This can be the easiest way to remove a visible seam in a rendering.

398 Symmetry and hyperNURBS

Providing there are no hidden faces lying against the mirror plane, you can apply a hyperNURBS object to a symmetry object and it will affect both sides as if they were connected.

Materials

399 Materials

Materials are fundamental to 3D graphics. They don't just provide
your models with color but also texture, which means you don't
need to model the intricacies of tree bark with millions of polygons.
Instead, you simply "paint" the illusion of texture onto a smooth
surface. The 3D aspect of a texture is called the Bump.

400 Creating materials

To create a material, simply double click in the Materials Manager
window. Use the drop-down File menu in the same window. Double
click on a material icon to edit its properties. The various aspects
of the material such as Bump, color, transparency, etc., will
only affect the texture if they are ticked in the Material Editor.

401 Applying materials

To apply a material, just drag and drop it onto an object in any of the viewports or in the
Objects Manager. If you want to apply it to just one part of an object, select the polygons
in question and drop the material onto them. The rest of the object will be unaffected.

402 Editing materials

To change the color of a material, open the material editor, select color from the menu
on the left, click on the small black arrow to the right of the Color field title, and adjust
the sliders. If you double click on the color field itself, you have further options for
adjustment methods.

403 Giving a material texture

The material color does not have to be uniform. To apply a texture, click on the arrow next
to the texture tab in the Color window of the Material Editor. Select Noise, for instance, and
then double click on the button that appears to edit its parameters in the Shader Properties
window. Aside from all the sliders and figures, another click on the Noise button will give
you lots of different patterns.

404 Combining texture and color

Use the Mix Strength slider to combine color and texture in the Color channel of a Material.

405 Bump channel

To create a texture with depth, use the Bump channel in the Material Editor. When used in conjunction with the same texture in the color channel, you can achieve remarkable results. Use the strength slider to adjust the depth effect of the texture.

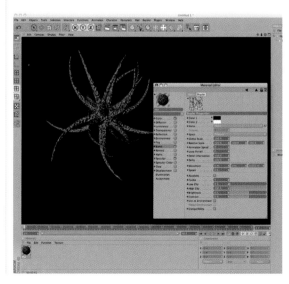

406 Using imported images for materials

You can use an imported image as a texture simply by selecting Load Image in the Texture Menu of the Color tab in the Material Manager. You can also apply an image to many of the other channels for some interesting effects, such as transparency and luminance.

407 Using Photoshop files with layers

To apply an image in several channels, it is possible to use a Photoshop file with layers. Place it in the Color channel and Bump channel, for instance, click on the Texture button in the channel dialog, and select a layer from the Layerset field. Aside from color, you will probably want your other layers to be black and white.

408 Material projection

Once a photographic texture has been applied to an object, it's important to choose the right mapping method. Click on the Material tag next to the object in the Object Manager. In the Attributes Manager the material Projection is specified. The choices are generally straightforward: cubic for cubes, spherical for spheres, etc.

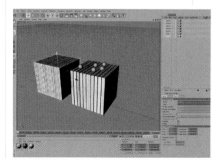

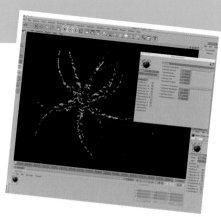

409 Material tiling

An image texture will repeat itself all across the object by default. If you want the image to appear just once, switch off tiling. If you want it to appear in a specific place, adjust its position with the Object tabs and scale its height and width with the Length fields.

410 Fitting materials

To make an image material fit snugly with the proportions of the object, right click the Material tab in the Object Manager and select Fit to Object.

411 Displacement

If you require more relief than the Bump channel can provide, try Displacement. Unlike Bump, which only simulates a texture, an image in Displacement actually moves polygons. You will need a highly divided object to make this work properly.

412 Shaders

An alternative to ordinary textures are Shaders. They are not dependent on positioning, projection, or tiles, but instead behave as if the object was actually made of the shader, rather than a texture that simply sits on its surface. Many shaders provide finishes that are impossible to create with textures and can be applied easily to awkward shapes.

413 Texture axis

If you need to move a material around on an object, use the Texture tool. Select the object not the Texture tag, and you can move, scale, and rotate the texture with the usual tools, independently of the object. This is great for jobs like placing a photo on an image of a wall.

414 Camera displacement mapping

If you want to composite a model with an image in C4D, use Camera mapping projection. Create a plane for the floor and for the background, and apply the same image to both, along with a Compositing tag (with Background Compositing switched on). The scene will be projected seamlessly on both planes in a rendering.

Lighting

415 Lighting

Lighting is often the key to a successful image—it adds atmosphere, depth, and realism. By default an ambient light illuminates the scene to prevent you working in the dark. As soon as a proper light is introduced, the ambient light disappears. Switch off the light you have created, and the scene will go dark.

416 Creating lights

To create a light, choose a type from the menu at the top of the C4D window. The first icon in the list is an Omni light, the most basic kind. A light can be moved around and rotated in just the same way as an object. Use the Attributes Manager to alter its color and intensity.

417 Light types

C4D offers many different types of light, some are more commonly used than others.

A **spot light** is perfect for illuminating a small area and will have to be rotated into position because it only shines in one direction. Use the toggles in the viewer to alter the width of the beam.

Area lights often provide the most realistic light; they are just like plane objects that glow. Stretch them out and angle them to get the effect you are looking for.

418 Shadows

Shadows are vital for providing interaction between shapes. If an object doesn't cast a shadow on the ground, it will appear to be floating. By default, lights cast no shadows. You can set them to do so in the Attributes Manager.

419 Shadow types

A hard or raytraced shadow renders quickly and has a hard edge. It usually looks unrealistic. A soft shadow has a soft edge and will take a little longer to render. This is not usually a problem unless there are transparent objects in your scene. Area shadows are the most realistic but can take a long time to calculate.

420 Visible light

The light source is invisible by default. To achieve the effect of a theater light shining through smoke, select Visible from the Visible Light pull-down menu in the Light's Attributes manager.

No light

Omni light–no shadow

Omni light–soft shadow

Spot light–soft shadow

Area light–soft shadow

Visible light

3ds Max
Simon Danaher

Autodesk's 3ds Max is very popular with 3D professionals, especially in the games industry.

For illustrators it has the potential to take work way beyond any 2D package, while at the same time allowing you to incorporate 2D artwork in your models. A good understanding of the rendering can even produce photo-realistic results.

Getting started

421 Open Close—Closing splines

When drawing spline or NURBS curves you have the option to create them open or closed. An example of a closed curve is a circle, while an open curve might be a U shape. To close a curve while drawing it, drag the last point over the first (or vice versa). An Open Close dialog box will appear where you can chose which type you want to create.

422 Navigate the viewport

You can navigate the Perspective viewport using the buttons at the bottom right of the interface. It is often more convenient, and faster, to use the keyboard shortcuts instead. To zoom/dolly, hold Control + Alt + middle drag. To orbit, hold Alt + middle drag, and to pan just middle drag.

423 Advanced navigation

There are two more advanced navigation options. Hold Control + middle drag to pan twice as fast and hold Shift to constrain the pan to the vertical or horizontal direction. This also works while orbiting the view (Shift + Alt + middle drag).

424 Smoothing polygon objects

Polygon objects are easy to work with but can appear faceted if their resolution is too low, yet high-resolution meshes are much more difficult to edit. The solution is to use a smoothing operation that takes the low-resolution mesh and outputs a high-resolution, smoothed version. You can still edit the low-res poly object, known as a cage, to control the high-res smoothed version.

425 Using Max's Subdivision Surface option

Max has a number of ways to smooth polygon meshes, such as the Mesh Smooth modifier. This works well but adds an extra layer to the modifier stack. In many cases it can be easier and more efficient to use the NURMS option in the Subdivision Surface roll-out in the Editable Poly modification options. In the image below the orange lines represent the low-res polygon object that has been smoothed. These can still be selected and edited to create details on the high-res object's surface.

426 Deleting vertices with edges

To remove the associated vertices when deleting edges, hold the Control key down while deleting the selected edges. You can delete edges, faces, or vertices using the Delete key on your keyboard.

427 The 3ds Max 3D interface

On launching Max you are presented with the default workspace comprising the familiar four 3D views. These are (clockwise from top left) Top view, Front view, Perspective view, and Left view. Clicking inside a viewport makes it "active" and it will be displayed with a yellow border. Clicking the Maximize Viewport toggle at the very bottom right of the interface will expand the active viewport to fill the whole view space.

428 Changing the layout

The four-view layout is not the only configuration Max offers. If you right-click the top left corner of a viewport and choose Configure, you access the Viewport Configuration dialog. In the Layouts tab you can choose from several different panel configurations. With one selected you can right-click in the Preview area to see which one of Max's panels will be displayed in each viewport. Here we've changed the large viewport to the Active Shade panel.

429 Setting up your project

When working in Max it makes sense to make use of the Set Project Folder option in the File menu. This lets you define a folder on your hard drive as the root of your current project. As you work in Max you will often need to open and save different files (such as the scene file, Xrefs, rendered images, and textures). These can all be stored in their own folders inside the project's root.

430 Creating Xref objects

An Xref is a link to an externally referenced file and is very useful. To create an Xref object in your scene choose File > Xref Objects to open the Xref panel. Clicking the first icon at the top right opens a file requester where you can search for a previously saved scene. Once selected you are presented with a Selection dialog from which you can choose the desired object to become the Xref.

431 Xref

With an Xref object in your scene you can do all the things you normally would, except edit it. To edit it you must open the original scene. One useful thing is that you can choose a low-res proxy for your Xref object and use that to set up the scene. If you make lots of instances of the object they will display as a low-res object, but when you render the scene the high-res Xref object will be used instead.

432 Shaded wire

When modeling objects it is essential to be able to see the edges and faces of the model. You can use wireframe view, but because you can see right through the object it can make selecting the right component difficult. Likewise in shaded mode the edges are not displayed. However, you can overlay a wireframe on top of the shaded view to give you the best of both worlds. Right click and choose Edged Faces from the display menu at the top left corner of a view to see a wireframe overlay.

Navigation tips

433 Navigation widget

The ViewCube sits at the top right corner of the screen by default and allows you to quickly change to any other view by clicking on its various sectors. Right click the cube to access a pop-up menu to switch the views between orthographic and perspective projection.

434 Steering Wheel

The Steering Wheel allows quick access to Orbit, Pan, and Zoom tools, and also adds flythrough/walkthrough modes which can be useful for interactively exploring an architectural scene or 3D environment using the mouse.

435 Quad menus

While you can use the main menus and tool buttons at the top of Max's interface, it can sometimes be a chore constantly having to take your focus off the 3D scene and run your mouse up to the top of the screen to change tools or choose a different view option, snap setting, etc. Instead, you can right click in the view to access a Quad menu pop-up, where some common tools and options can more quickly be found.

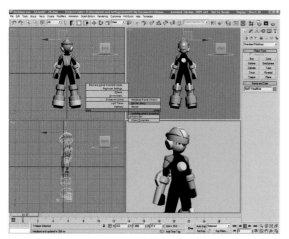

Snap Settings and Transform Gizmo

438 Happy Snappy

Snapping is a handy feature in any 3D program because it allows you to model objects easily and accurately by having them or their components (points, edges, faces, etc.) snap precisely to scene elements or the grid. To enable snapping choose either 3D, 2.5D, or 2D from the first snap tool (it looks like a horseshoe magnet) in the Menu bar. This NURBS curve was drawn using snapping to place the CV points accurately on the grid.

436 Alternative Quads

Different Quad menus can be accessed by holding down different key combinations. For example, to access the rendering Quad menu hold Control-Alt and right click, while for snap settings and overrides you hold Shift and right click. Custom Quad menus can be assigned the combination Shift-Control-right-click.

439 Snap settings

Right click on the Snap tool button to open the Snap Settings panel. Here you can choose what elements you can snap to. By default, Grid points is selected, but you can also choose various geometry components such as Vertex instead. Here only vertex snapping is enabled. The NURBS curves were then drawn on the surface of the polygon sphere by snapping to its vertices.

437 Custom Quads

If you've got into the habit of using the Quad menus, you might find that you'd like to customize them. Choose Customize > Customize User Interface from the main menu to open the Customize panel and click the Quads tab. Here you can add and remove menu entries for each of the different Quad menus, and even design your own from scratch.

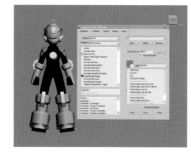

440 3D, 2.5D, and 2D snapping

There are three types of snapping: 3D snapping will snap in full 3D space, 2.5D will snap to geometry in pseudo-3D depending on the view, and 2D snapping will snap only to the grid plane. Here 2.5D snapping lets you trace the vertices in Left view to snap to the vertices of an object without moving them perpendicularly.

443 Toolbar tips

Right clicking the toolbar displays a pop-up menu with options for selecting different toolbar items. Here you can select Snap settings, Render presets, and more. You can also choose to show or hide the command panel normally displayed on the right side of the interface.

444 Customizing the Transform Gizmo

When interacting with objects using the Transform gizmo, the set of red, green, and blue axes, handles, or rings, can be altered. For example the - and + keys will scale the gizmo making it larger or smaller, while hitting the x key will hide the gizmo. This can be useful when you don't want the handles cluttering up the view or obscuring some detail.

441 Translating gizmo orientation

When translating objects (by moving, rotating, or scaling them), you need to choose the orientation of the translate gizmo relative to the object. There are several options selectable from the menu to the right of the Translate tools in the tool bar. In the image above, Local is chosen for the right object because it has been rotated and we want to move it only in the direction it is pointing (its Local z axis).

442 Effects on scaling

The most dramatic effect of choosing an inappropriate gizmo orientation can be seen when scaling an object that has previously been rotated. In the image on the right, the left object was scaled in z using the gizmo in Local mode while the right object has been scaled using World mode. You can see that the latter object has been distorted due to the orientation of the mode used.

445 Spacebar shortcut

The spacebar is a useful toggle that is used to lock or unlock selections. Tapping it while an object is selected will lock the selection, preventing you from accidentally deselecting the object or selecting some other object. This is particularly useful when moving an object that's behind another.

446 Making accurate transformations

Use the Transform type-in boxes at the bottom of the screen for precise transformations. For example, if you want to reposition an object at the center of the scene, make sure you're in World mode and have the Move tool active, then enter 0, 0, 0 into the boxes, pressing the Tab key between each 0.

447 Assembling objects hierarchically

When creating a scene or an object made from many smaller objects, you'll generally want to assemble them in a hierarchy so that if the topmost object (the parent) is moved all the subobjects (the children) move as well. A car could have its wheels as children of the body shell so that wheels will move with it, for example.

Hierarchies

448 Hierarchy using the Link tool

There are a few different ways to create hierarchies in Max. The simplest is to use the Link tool in the main toolbar. With this active, you select the objects you want to be children and drag your mouse onto the object you want to be their parent. It gets messy when there are lots of objects though.

449 Hierarchy using the Group tool

Grouping objects is another way to create a hierarchy in Max, and this is generally better when you have lots of objects you want to group together. Select all the objects first then choose Group > Group from the main menu.

450 Scene Explorer

A more advanced way to create hierarchies, and hierarchies within hierarchies, is by using the Scene Explorer. Here you shift-select multiple objects, and drag and drop them onto a parent object. A yellow arrow highlights the move and children are subsequently displayed indented under their parent.

451 Sweeping pipes

The Sweep modifier is a quick way to create pipe-like objects in Max. First you draw a path using any of the line-drawing tools or primitives, then simply add the Sweep modifier. It even comes with a list of profile presets for quickly creating pipes, beams, and bars, or you can draw your own profile and use that.

452 Object snapping with the Align Tool

Use the Normal Align tool (third in the Align toolbar button set) to quickly snap and align one object to another. Select the bottom face on the object you wish to align, then click on the face of the object you wish it to snap to. The object snaps to the selection and is precisely aligned to it.

Rendering and Materials

453 Interactive highlight placement

Another tool in the Align button set is Place Highlights. This allows you to choose exactly where on an object a highlight will be cast from a given light. The tool interactively moves the light as your mouse travels over the object's surface, giving you instant feedback in Shaded mode.

454 Steering Wheels in Max

Shift-w toggles the display of the Steering Wheels while right clicking gets rid of it quickly. Steering wheel options can be accessed from the menu at the bottom right corner of the Widget and the Views > Steering Wheels menu.

455 Enabling the Mental Ray renderer

Mental Ray is an additional render engine that comes with Max. You must enable it before you can create realistic lighting using Global Illumination or Final Gather. Enable Mental Ray in the Assign Renderer section in the Common tab of the Render Setup.

456 Partial rerendering of animations

If during an animation you need to rerender certain frames (perhaps you forgot to enable motion blur, or neglected to alter an errant material), you can do so without rendering the whole sequence again by checking the Frames option in Render Setup. Separate frames with a comma, and indicate frame ranges with a hyphen (for example, 23-35, 230-255).

457 Environment mapping

To change the mapping coordinates of an environment background image, drag it (and choose Instance) from the Environment and Effects panel into a spare slot in the Material Editor. Change the Mapping type from the Mapping drop-down in the Coordinates section of the material.

458 Fresnel reflection falloff

Create accurate reflection falloff by first adding a Raytrace shader in the Reflection channel of a material, then a Falloff shader in the Reflectivity/Opacity map section of the Raytrace shader. Set the Falloff type to Perpendicular/Parallel and the Direction to Viewing Direction (Camera Z-axis).

459 Reflection depth in Mental Ray

Control the number of reflection bounces between objects using the Max Trace Depth and Max Reflections settings in the Rendering Algorithms section of the Renderer tab in Render Settings. Increasing the depth will create more reflections between reflective objects but will take longer to render.

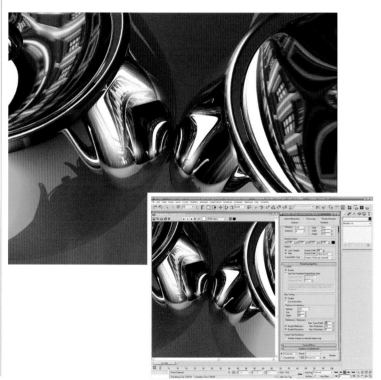

460 Reflection optimization

If you don't need to see lots of recursive reflections, then reducing the Max trace depth to 2 or 3 will make the scene render faster without too much impact on the look, especially if there are many reflective surfaces in your scene.

461 Faking reflections

Sometimes disabling raytraced reflections and using an environment map instead is sufficient for creating shiny metals and other such surfaces. The downside is that the result is not quite as realistic, but sometimes this can be beneficial.

462 Expand the Command palette

The Command Panel on the left can become cramped when working with some modifiers that have lots of roll-outs. You can make more space for yourself by dragging the left edge of the panel to make it two, three, or even four columns wide.

463 Bigger material preview

The preview in the Material Editor is quite small—too small to see the details of a subtle bump map for example. To get a close view without having to render a whole frame, right click on the preview ball and choose Magnify.

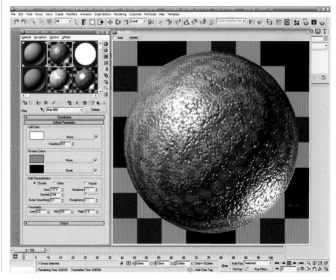

464 Remember to save incrementally

Save incremental versions of your scene as you work by choosing Save Copy As from the File menu. Each time you do so the file name will have a number appended incrementally, providing you with a history of past progress.

465 Customized material previews

Create a custom Material Editor preview object by saving a scene with only the desired object in it and with a UVW Map modifier applied. Make sure the object is less than 100 units on each side. Choose Options > Options from the Material Editor menu and load the scene in the Custom Sample Object slot. Choose your custom object from the Sample Type pop-up.

466 Instancing shaders

If you want to use the same shader or texture between multiple materials, you can right click on the shader name in its slot in the "master" material and choose Copy. Right click again in the slot of the destination material but choose Paste (Instance). Any change you make to the master will automatically update the instance.

Modeling

467 Editable Mesh versus Editable Poly

When converting objects to Editable Mesh or Poly, bear in mind the difference. While Mesh objects look similar in the 3D view their faces are actually made of triangles. Poly objects can have faces with any number of points.

468 NURMS polygon smoothing

Poly objects can be turned into smoothed surfaces using the NURMS toggle. Just right click to access the Quad menu and choose NURMS Toggle for the menu.

469 Polygons into NURBS surfaces

Mesh or Polygon objects can be converted to NURBS surfaces, firstly by converting to Editable Patches, then to NURBS. Be careful, though, because it's very easy to create polygon surfaces that do not work well when converted to NURBS.

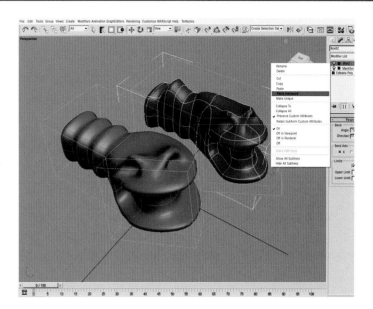

470 NURBS control

If you want to smooth a polygon object and have access to extra controls, then you can add a smooth modifier such as MeshSmooth. MeshSmooth allows you to edit the control cage and different levels of subdivision simultaneously, here at level 1 and also level 2 (eye sockets).

471 Viewing the effect of the stack

When editing different modifiers in the stack, Max automatically disables those modifiers above the one currently selected. If you want to see the final result while you work, click the Show End Result toggle (it looks like a half-full test-tube).

472 Disabling modifiers

Modifiers can be temporarily disabled by clicking the lightbulb icon next to their names in the modifier stack list.

473 Instancing modifiers

Modifiers can be copied and pasted between different objects. Say you have a bend modifier already set up and want the same effect applied to another object, just right click and choose Copy on the modifier name, and paste it into the other object's stack. Choose Paste Instance to link the master and the copy.

474 Shape view editing

Shape View is a useful 2D view when editing splines and other profiles. Shape View shows you a full-frame view of your selected shape face on, no matter what its orientation or location in the scene. This makes editing the profile of a loft object, for example, much easier.

475 Extended Undos

You can increase the number of Undos that Max allows by default from 20 to any number you like (memory permitting), from the main Preference Settings dialog box.

476 Select and Manipulate

Use the Select and Manipulate button in the main toolbar to edit certain properties of parametric objects and lights interactively in the 3D view without having to use the Modify panel and rollouts.

477 UVW Projections

In order to apply a bitmap texture to a 3D object, you must first define a projection for it. To do this, add a UVW Mapping modifier to your object and then choose the projection that is the closest fit from those offered.

Creating tips

478 Stylized photorealism

When creating illustrations in 3D, think about the medium and how you can use it to create artistic effects. Photorealism is only one approach, but you can also create stylized photoreal situations in 3D that are both realistic and artistic, such as this rendering of a car.

479 Illustrator artwork as 3D curves

You can make use of the powerful drawing tools in Illustrator and import the artwork in Max for use as source curves for creating 3D objects. Use Save As and save the art as Illustrator 3, not as Illustrator EPS.

480 3D objects from Illustrator art

When opening Illustrator artwork, use the File > Import command, not Open. The imported files behave just like Max line objects and can be used to create 3D geometry. Here an Edit Poly modifier is added to create a 3D logo.

481 Multi-pass rendering

You can split a rendering into "passes" so that, for example, the reflections, highlights, and shadows are stored in different files. Load these as Layers in Photoshop to adjust their relative contribution to the final image. It's much quicker than rerendering.

482 Multi-pass blending modes

When using multiple passes you need to make use of layer blending modes to get the correct result. Here are a suggested layer order and blending modes for each layer from bottom to top: Diffuse-Normal, Shadow-Multiply, Reflection-Screen (or Linear Dodge), Specular-Screen (or Linear Dodge).

483 Making material choices

Be creative with materials. Applying unusual or incongruous materials to objects is a simple way to create stylized imagery using otherwise rather ordinary 3D models.

484 Particle systems

Max's particle system is a useful tool for creating all kinds of interesting effects. Here it's been used to make streaking raindrops. Rather than points, the particles were long and narrow instanced cylinders, which were then slightly motion-blurred in Photoshop.

485 Getting creative

Interesting backgrounds and abstract compositions can be created using simply constructed geometry and materials. A combination of photoreal rendering and abstract composition can be creatively compelling.

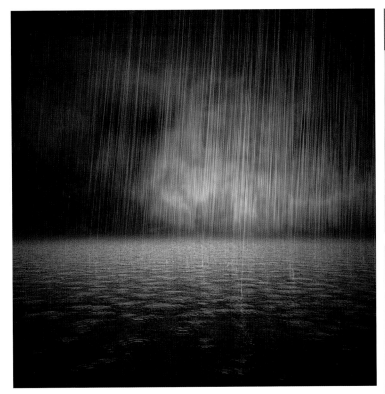

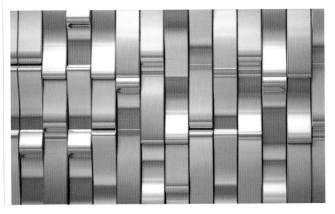

486 Control highlight brightness

Lighting is an art that can take a long time to master. When rendering, try to make sure that highlights are not totally blown out. It's far easier to brighten dull highlights in Photoshop; clipped ones can never be adjusted for.

487 Post-rendering exposure

Make use of Max's exposure control. It gives you a mini-preview of the adjustment and computes the effect at render time, ensuring maximum output quality.

488 Editing UVW projections

A UVW Mapping projection can be scaled and rotated in the 3D view to fit the object better or to create variable tiling effects. Click the Manipulate button in the Modifier to display extra handles in the viewport that you can drag.

489 UVW mapping: Normal Align option

Normal Align mode is a very useful way to align Planar projections interactively to surfaces on your model. When clicking Manipulate in the UVW Mapping modifier and dragging on the model, this mode rotates the map so it is perpendicular to the surface under your mouse.

490 Viewport textures

To view textures applied to objects in the viewports, you must enable their visibility from the Material Editor. Click the checkered cube button to activate textures for the selected material.

Animation

491 Creative animation for stills

Make use of animation even if you're creating a still illustration. For example, you can animate the deformation of an object and render out various frames of the object in varying states to create interesting montages or effects.

492 Think laterally

Try using tools in ways for which they were not necessarily designed. Be creative. For example, use Max as an auxiliary and powerful Photoshop filter. For example, import an in-progress illustration as a texture, apply it to a plane, and distort it in 3D.

493 Onion skinning

The Show Ghosting option in the main View menu turns on the effect also known as "onion skinning" to animators. This useful visual aid displays the state or position of your animated object at keyframes in wireframe in the main display.

494 Reduce keyframe option

Function curves graphically show how animated values change over time. You can draw your own curves using the Draw Curves tool in the Track View, but this will result in lots of keyframes. To rectify this, simply apply the Reduce Keys command in the Keys menu, enter a threshold, and click OK. The new curve will have only a few keys but be similar in shape.

495 Drawing in a judder

The Draw Keys tool is a neat way to add judder or impact effects to objects, since you can sketch directly on an existing curve adding a rough hand-drawn sine wave to create a neat judder in your otherwise smooth animation.

496 Mini-Curve animation editor

The animation timeline can be expanded by clicking the small button to the far left of it to reveal the mini-curve editor view. This makes it easier to see how the animated values change over time.

497 Expanding the Mini-Curve view

The mini-curve editor view can be expanded by dragging the small section of its top edge to the right of its toolbar. The cursor turns to a double-headed arrow to indicate that you are over the right spot.

498 Autokeying saves time

Autokeying in 3ds Max is a quick and easy way to animate objects and parameters. Simply click the autokey button, then move the time slider to a different frame and move your object again. Your object will now be animated.

499 Precise keyframe control

More control over keying can be done using Set Key mode. When this mode is switched on, keys are only created when you click the big Keyframe button. This helps to prevent accidentally created or unnecessary keys.

500 Frugal keyframing

When animating it is best to keep the number of keyframes to a minimum and to only key parameters that you want to change over time. When in Set Key mode you can use the Key Filters button to choose exactly which parameters will be animated (for example, you can disable Scale and Rotate to only the keyframe Position).

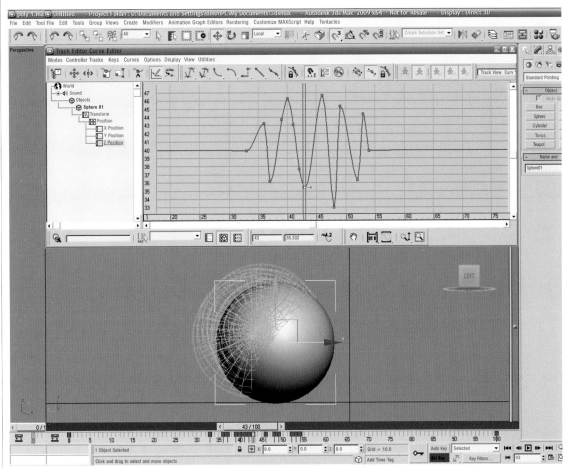

Glossary

AIFF
Audio Interchange File Format. An audio file format standard used for storing sound data for personal computers and other electronic audio devices.

Bitmap
A bitmap is a common term for a pixel-based image. Also called a raster image, this describes a grid of pixels arranged in a checkerboard-like arrangement.

Child
An object below a parent in the Object Manager's hierarchy that will be affected by the Parent's attributes.

CMYK
Cyan, Magenta, Yellow, Black. Printed digital images, whether reproduced for magazines or posters, or printed with an ink jet printer, use the CMYK format.

Extrude
Creating a 3D object based on a 2D profile, usually a spline, by projecting away from the spline in the third dimension, making for instance, a cylinder from a circle.

Frame rate
Number of frames displayed per second within an animated sequence.

GIF
Graphic Interchange Format. A universal image format designed for monitor and network use only. Not suitable for saving photographic images or digital illustrations due to its 256-color, 8-bit palette.

HyperNURBS
A hyperNURBS object, when used as a parent, will round off and soften its child object. The use of hyperNURBS objects allows the creation of very smooth surfaces with a small number of polygons, reducing file size and render times.

JPEG
Joint Photographic Experts Group. A format which compresses a digital image to reduce its file size and resolution by removing a percentage of its pixels. The quality of a JPEG depends on the amount and method of compression.

Keyframe
A keyframe in animation and filmmaking is a drawing which defines the start and end points of any smooth transition. They are called "frames" because their position in time is measured in frames on a strip of film. A sequence of keyframes defines which movement the spectator will see, whereas the position of the keyframes on the film, video, or animation defines the timing of the movement. Because only two or three keyframes over the span of a second does not create the illusion of movement, the remaining frames are filled with inbetweens.

Layers
One of the most important features of imaging software is the ability to work in layers, which allow different elements of the composition, or other images montaged onto the composition, to be worked on individually.

Levels
Along with Curves in Photoshop, using Levels is one of the best methods to adjust the exposure and tonality of an image. It is also possible to adjust the red, green, and blue channels individually for fine control, or for distorting the color range.

MovieClip
In Flash, a MovieClip is one of three types of symbol (the other two being graphics and buttons). MovieClips have their own timeline and can contain anything from a simple shape in a single frame to multiple animated layers over many frames.

MP3
Digital audio encoding format using a form of lossy data compression. It is a common audio format for consumer audio storage, as well as a de facto standard encoding for the transfer and playback of music on digital audio players.

NURBS
Nonuniform Rational B-spline. A system of using coordinates in 3D to define curves and surfaces. NURBS have control points that can be repositioned in order to change the shape of the object they define.

NURMS
Nonuniform Rational Mesh Smooth. NURMS are used in commercial 3D packages such as 3ds Max to perform mesh smoothing operations. The mesh smooth modifier in 3ds Max operates by applying this algorithm to a low-polygon mesh and creates a high-polygon smoothed mesh. NURMS is also the name of an Adobe Illustrator filter that uses the same algorithm of smoothing, but only for 2D curves.

Parent
An object in the Object Manager that contains other elements known as children. The parent can be a NURBS object or modeling object that affects the children within it, or a Null object whose tags and attributes will affect all its children.

PDF
Portable Document Format. This is a very useful format, which compresses images and files to be displayed in a multipage document that is convenient to send as an email attachment and can be opened on any computer with a PDF viewer. Each PDF file encapsulates a complete description of a fixed-layout 2D document that includes the text, fonts, images, and 2D vector graphics which comprise the documents.

Pixel
Digital images are composed of pixels, which are tiny, colored squares containing the basic mathematical information that determines their tone and color. When viewed together, often in the millions, pixels give the impression of continuous tone, similar to the ink dots on a printed page that make a photographic reproduction.

Primitive
A simple geometric object such as a cube or cylinder defined by parameters specific to its shape. Primitives often form the starting point for modeling more complex shapes, but must be made editable before changes to their shape can be made.

Render

To calculate the incidence of light on the surfaces and textures within a scene in a 3D package to create a finished image.

Resolution

The resolution of a digital image is expressed in ppi (pixels per inch). The higher the ppi the higher the resolution. It is advisable to work on images at a relatively high resolution (300ppi), though this will depend on the final output.

RGB

Red, Green, and Blue are the principal colors which, when combined (as projected light) will make white. This is is the standard color mode used for working on digital images on the computer.

RIFF

Resource Interchange File Format. A generic meta-format for storing data in tagged chunks.

Spline

A curve defined by vectors called anchor points and handles, protruding from selected anchor points allowing the manipulation of the curve between two or more points.

Tag

Tags are chosen from the Tags menu and dropped onto objects in order to endow them with a specific attribute such as visibility or smoothing. They appear adjacent and to the right of the object in the Objects Manager.

TIFF

Tagged Image File Format. The most common cross-platform image format. Compressed TIFFs use a lossless routine which unlike JPEGs maintain all the digital information.

Timeline

The area on the screen where you work with layers and frames to alter a Flash movie's content and animation. A movie is a collection of frames and the timeline is the area in Flash where you will be configuring those frames.

Tween, tweening

Short for in-betweening, this is the process of generating intermediate frames between two images to give the appearance that the first image evolves smoothly into the second image.

Vector

A point defined by coordinates that, combined with other points, defines a path or area for the purposes of representing a line or surface either in 2D or 3D.

WAV

Waveform Audio Format. A Microsoft and IBM audio file format standard for storing an audio bitstream on PCs. It is the main format used on Windows systems for raw and typically uncompressed audio.

Web safe

A limited set of fonts or colors that can be (virtually) guaranteed to display correctly on all computer systems.

Wireframe

A representation of a 3D model as unshaded polygons or splines. A wireframe is useful for viewing a model's structural details.

Xref

A link to an externally referenced file.

Index

About the authors

Luke Herriott
Luke has been art directing, designing, and managing book projects for over 15 years. A former Art Director at the highly acclaimed international publisher RotoVision, he is now Director of his own book design and packaging company Studio Ink. He is author and designer of *1,000 Restaurant, Bar, and Café Graphics*, published by Rockport Publishers, and has also coauthored and compiled a number of titles for RotoVision including, *Instant Graphics*, *First Steps in Digital Design*, *The Packaging and Design Templates Sourcebook*, and *The Designer's Packaging Bible*.

Robert Brandt
Robert Brandt's love of all kinds of visual communication has led him to produce illustrations and designs for books, advertisements, presentations, and products in more styles than he can count for publishers and companies all over the world.

Hannah Gal
Hannah is an award-winning creative and writer. A Beck's Future's nominee, she exhibits extensively worldwide. Credits include Adobe, Apple, MTV, BBC1, CNN, *The New Yorker*, *Sports Illustrated*, Amnesty International, *The Times*, *MacUser*, *MacWorld*, *The Guardian*, *The Independent*, *Artist and Illustrator*, and *Creative Review*, among many others. A contributor to *PhotoshopCreative*, *Corel* magazine, *The British Journal of Photography*, and *Photo District News*, she speaks on digital creativity to the likes of The Media Trust, the Apple store, and Adobe.

Jim McCall
Jim has 11 years experience as an illustrator and has been a digital art director in two large agencies. He is now both the Digital Director and Managing Director of creative digital marketing agency, The Unit (www.theunit.co.uk)

Simon Danaher
Simon produces images for the advertising industry and illustrations for books and magazines. In 2007 his work won the Grand Prix at Cannes International Advertising Awards. He has also written several books on 3D and 2D graphics as well as many articles for the UK creative press.

Acknowledgments

The authors would like to thank their editor, Jane Roe, and Art Director, Tony Seddon, at RotoVision for their help and support on this project. Jim McCall would also like to thank Justin Cross at Island Records, Sean Worrell at MTV Networks, Alison Atkinson at London Philharmonic Orchestra, JimMedway.com, plus Natalie, Arthur, and Anna.